W9-AHN-363

IMAGES
of America

US National
Library of Medicine

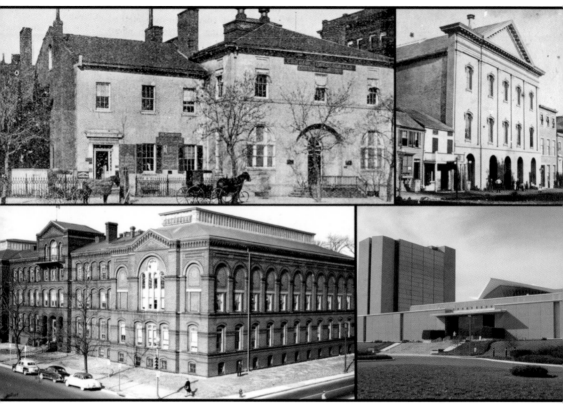

This collage shows the locations of the US National Library of Medicine and its predecessor institutions from 1862 to the present. From left to right are, (top row) Riggs Bank Building, Washington, DC (1862–1866) and Ford's Theatre, Washington, DC (1866–1887); (bottom row) the "Old Red Brick" building on the National Mall (1887–1962) and the campus of the National Institutes of Health, Department of Health and Human Services, Bethesda, Maryland (1962–present). (Courtesy US National Library of Medicine.)

ON THE COVER: The US National Library of Medicine occupies a unique and historic set of buildings on the campus of the National Institutes of Health in Bethesda, Maryland. (Courtesy US National Library of Medicine.)

IMAGES
of America

US NATIONAL
LIBRARY OF MEDICINE

Jeffrey S. Reznick and Kenneth M. Koyle
with staff of the
US National Library of Medicine

ARCADIA
PUBLISHING

The Intramural Research Program of the US National Institutes of Health, National Library of Medicine, supported the research, writing, and editing of this book by Jeffrey S. Reznick, Kenneth M. Koyle, and staff of the US National Library of Medicine. All rights reserved, 2017.

ISBN 978-1-4671-2608-3

Published by Arcadia Publishing
Charleston, South Carolina

Printed in the United States of America

Library of Congress Control Number: 2017931439

For all general information, please contact Arcadia Publishing:
Telephone 843-853-2070
Fax 843-853-0044
E-mail sales@arcadiapublishing.com
For customer service and orders:
Toll-Free 1-888-313-2665

Visit us on the Internet at www.arcadiapublishing.com

*To the staff of the US National Library of
Medicine—past, present, and future.*

CONTENTS

ACKNOWLEDGMENTS

Many colleagues and friends within and beyond the library contributed their time and talent to make this book a reality. For supporting the fundamental research and writing of this book, we would like to thank the Intramural Research Program of the US National Institutes of Health, National Library of Medicine, as well as the leadership of the library, including Patricia Flatley Brennan, Betsy L. Humphreys, Milton Corn, and Joyce E.B. Backus.

Among those who deserve special thanks are our chapter authors Stephen J. Greenberg, James Labosier, Anne Rothfeld, and Susan L. Speaker, all of whom also contributed to identifying many of the wonderful images that appear in this book. Additionally, many individuals within and beyond the library devoted their time and expertise to locating, organizing, and preparing images; researching and writing image captions; and offering critical feedback on drafts of the manuscript. We would especially like to thank Ginny Roth, Douglas Atkins, and Kendra Ireigbe for researching, locating, and reproducing so skillfully the many images from the library's collections, as well as Stephen J. Greenberg for producing several new complementary photographs. And for their own contributions, which combined to inspire, create, and realize this book, we also thank Anne Altemus, Dianne Babski, Jai Lin Baldwin, Lenore Barbian, Roxanne Beatty, Dennis Benson, Dale Berkley, Eric Boyle, Ernie Branson, Carole Brown, Allen Browne, Patricia Carson, Dan Caughey, Ba Ba Chang, Timothy E. Clark Jr., Nicole Contaxis, Kathleen Cravedi, Laura Cutter, Dora Deegbe, Tory Detweiler, Kathel Dunn, Sarah Eilers, Elizabeth Fee, Martha Fishel, Reginald Frazier, David Gillikin, Alan Hawk, Troy Hill, Mary Holt, Chianti Kight, Ken Kletter, Lou Knecht, Sheldon Kotzin, Conni Koyle, Melvin R. Laird, Janet Laylor, Mary Ann Leonard, Donald A.B. Lindberg, Becky Lyon, Jessica Marcotte, Jane Markowitz, Jennifer Marill, Mary Fogarty McAndrew, Melanie Modlin, Christie Moffatt, Beth Mullen, Jill Newmark, Thanhxuan Nguyen, Michael North, Carlo Nuss, John Parascandola, Greg Pike, Scott Podolsky, John Rees, Allison Reznick, Bernard Reznick, Danielle Reznick, Rachel Reznick, Michael Rhode, Michael Sappol, Paul Sledzik, Dale Smith, Kent Smith, Brian Spatola, Heidi Stover, Krista Stracka, Patricia Tuohy, Sandy Triolo, Rebecca Warlow, and Lindsay Williams.

Henry Clougherty, Caitrin Cunningham, Mike Kinsella, Erin Vosgien, and the entire team at Arcadia Publishing offered generous support during the course of conceptualizing and producing this book. We are especially grateful to Arcadia for making a digital version of this book freely available in respect of the US government public access policy for publicly-supported research and writing.

Unless otherwise noted, all images are courtesy of the US National Library of Medicine.

—Jeffrey S. Reznick and Kenneth M. Koyle
Bethesda, Maryland
April 2017

INTRODUCTION

If you enjoy history and libraries—and the history of libraries—then you are going to enjoy this thematic and visual history of the US National Library of Medicine, the world's largest biomedical library, which is located in Bethesda, Maryland, on the campus of the National Institutes of Health, one of the world's foremost medical research centers.

Many individuals have written about the National Library of Medicine and its origins as the Library of the Surgeon General's Office. However, this book is unlike previous publications. It is expressly intended as a general introduction to the history of the library primarily through its own rich image collections and a handful of others selected from the collections of the National Archives, the National Museum of Health and Medicine, the Smithsonian Institution Archives, and the Rudolph Matas Library of the Health Sciences at Tulane University. This book is also different from earlier publications because it showcases the research and writing talent of our colleagues at the library, including archivists, conservators, curators, historians, librarians, and technical specialists. Every day these individuals care for, curate, and provide public access to one of the world's finest collections of historical material related to human health and disease. Built over many years, passed down from one generation to the next, and including material from antiquity to the present and from virtually every part of the world, this collection includes books, journals, manuscripts, photographs, films and videos, artwork, postcards, pamphlets, websites, social media, scientific data, and much more. It is truly an international treasure that reflects a global and centuries-long record of medicine of great value to researchers, educators, and students from across the disciplines. For more than 180 years, these collections have circulated to individuals within and beyond the reading rooms of the library's various locations in and around Washington, DC. Today, many of these collections—as part of the trillions of bytes of data produced, delivered, and interpreted by the library—circulate daily to millions of people around the world, including scientists, health professionals, scholars, educators, students, and the general public.

As the library anticipates its third century of public service, we offer this overview of its origins in the early 19th century, from a few dozen books in what was then the Library of the Surgeon General's Office of the US Army to its development into the late 20th century. Over this long period, as you will see, the library has developed into an institution of technical innovation, visionary leadership, and skillful work completed by a diverse and dedicated cadre of civil servants. Its history reflects the history of America and the world—the US Civil War, the world wars, the Cold War, and the dawn of the Information Age.

We hope you will enjoy this history of the library as much as we have enjoyed crafting it in cooperation with so many colleagues and friends. We hope it will inspire you to learn more about the development of the library through the free resources listed in the bibliography, and to learn more about our institution as it exists today and serves the world from its home on the campus of the National Institutes of Health. You can explore our collections, programs, and resources online at www.nlm.nih.gov. Or visit us in Bethesda, Maryland, for a tour or to conduct your own research in our collections. We warmly welcome you!

One

ORIGINS AND EARLY YEARS

The official history of the US National Library of Medicine begins in 1836, with the first documented request for funding from the secretary of war to purchase medical books. However, the roots of the library originated 18 years earlier than this request, in the establishment of the US Army Medical Department and the appointment of the first surgeon general, 30-year-old Joseph Lovell. It was in the office of this young surgeon general that the first few books, which were from Lovell's personal collection, took their place on a shelf and became the seeds of what would eventually grow to be the world's largest biomedical library.

The US Army Medical Department in 1818 was small, scattered, and insufficient for its mission. Despite this, Lovell was determined to succeed. Medical officers at the time did not hold regular officer rank, but were instead referred to by the titles surgeon or assistant surgeon. Lovell worked tirelessly to ensure that the department's surgeons and assistant surgeons could provide the best possible care to the widespread Army. The state of medical practice across the young nation was haphazard and disparate, ranging from highly educated, scientifically minded physicians who had studied at the best schools in Europe to apprentice-trained doctors who had never set foot in a university classroom and had only been exposed to the narrow group of patients available in their small, frontier towns. In order to raise the standards of care and enable his officers to remain current on the latest advances in science and medicine, Lovell subscribed to medical journals for each surgeon and assistant surgeon. In addition to the journal subscriptions, the Surgeon General's Office provided each post and regiment with a standard set of books on anatomy, surgery, and medical practice.

Prior to 1836, there was no specific budget allocation for medical publications. Instead, a few hundred dollars would be designated for operational necessities, such as books and medical supplies. Lovell was meticulous and careful with his tiny budget, tracking every expenditure and taking pride in the occasions when he could demonstrate a reduction in the cost for medical support. However, throughout his tenure as surgeon general, it appears that he neither requested nor received funding directly linked to procuring books for a medical library. When Lovell died of pneumonia in October 1836, Assistant Surgeon Benjamin King, who was the senior medical officer serving in Washington at the time, assumed control of the office until President Andrew Jackson could appoint a new surgeon general. The budget request for the coming year had to be submitted to the secretary of war during King's short time as interim surgeon general, and he included $150 for medical books in the request. This was the first funding request specifically identifying books for the Library of the Surgeon General's Office, and it is with this document that the US National Library of Medicine marks the beginning of its history.

On November 30, 1836, President Jackson selected Thomas Lawson to succeed Lovell as surgeon general. Under Lawson's leadership, the small collection of books blossomed into a legitimate library. Lawson continued to include funding for books in his annual budget requests, and in 1840, an unidentified staff member in the office compiled the first known catalog of publications in the Library of the Surgeon General's Office. The handwritten inventory listed 134 titles, including eight journals. Small though it was, the library included the current standards of medical and scientific literature, along with a few volumes of general scholarly interest.

During this period, the recording of meteorological data became one of the unique tasks assigned by the Army's leadership to its medical officers at frontier posts. Such data collection had been undertaken almost since the establishment of the medical department, primarily to study the suspected links between climate and disease. Joseph Lovell published the first compilation of this data in 1826, covering the years 1822 to 1825, and in 1840, Lawson proposed that his staff draft a more detailed report examining the data from the subsequent five-year period. He published this report as the *Meteorological Register for the Years 1826–1830*, appending Lovell's earlier compilation so that the new book covered nine years of weather data. Along with this book, Lawson had his staff conduct a thorough analysis of medical reports from the field, creating a second text called *Sickness and Mortality in the Army of the United States*. These two volumes provided Lawson with an alternate means of growing the collection: book exchanges. Lawson sent the books produced by his office to the Medical Department of the British Army and to the libraries at Harvard College and the Philadelphia College of Medicine. In return, the recipients sent copies of their own publications to Lawson. The library also grew with gifts and donations of various kinds. Occasionally, the author of a medical text sent copies to the Office of the Surgeon General, hoping to gain publicity that would translate to more sales. Publishers of journals and medical books sent free sample copies to Lawson, attempting to entice him to make purchases for his office and for the burgeoning cadre of medical officers in the field. And of course, sometimes medical professionals, either those affiliated with the Army or simply supportive of the military mission, donated books from their personal collections to the library.

Thomas Lawson served as the surgeon general for 25 years, the longest tenure of anyone in that position. In 1840, four years after he took office, the library contained a mere 134 titles. Three years after his death, in May 1861, the number of titles was approaching 500. The Library of the Surgeon General's Office of the US Army was still small, but it was firmly established and growing. During and following the Civil War, Lawson's successors built upon this foundation to create an institution worthy of its name.

—Kenneth M. Koyle

Joseph Lovell (1788–1836) was the first surgeon general of the US Army Medical Department, from 1818 to 1836. Previously, others had been charged with oversight of the Army's medical support, but until Congress reorganized the Army staff and appointed Lovell in 1818, there was no permanent position of surgeon general.

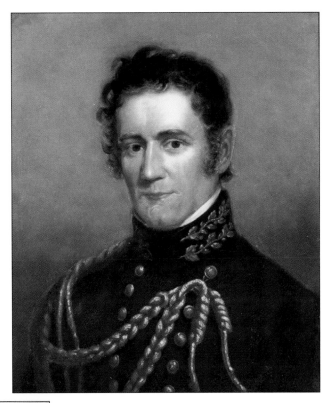

The *Medico-Chirurgical Journal and Review* was the standard journal distributed by the Office of the Surgeon General during the early days of the US Army Medical Department, but some officers requested subscriptions to different medical publications.

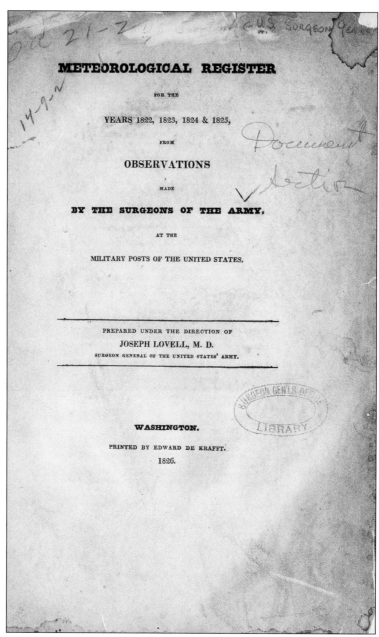

METEOROLOGICAL REGISTER

FOR THE

YEARS 1822, 1823, 1824 & 1825,

FROM

OBSERVATIONS

MADE

BY THE SURGEONS OF THE ARMY,

AT THE

MILITARY POSTS OF THE UNITED STATES,

PREPARED UNDER THE DIRECTION OF

JOSEPH LOVELL, M. D.

SURGEON GENERAL OF THE UNITED STATES' ARMY.

WASHINGTON.

PRINTED BY EDWARD DE KRAFFT.

1826.

The *Meteorological Register* was prepared by Surgeon General Joseph Lovell. He recognized that there was a unique opportunity in the United States to examine and record the impact of population growth, agriculture, and deforestation on the environment, an opportunity that did not exist in Europe because the spread of civilization there had taken place over millennia rather than over the course of a few decades, as was happening in early-19th-century North America. As Lovell stated, he prepared his tables "in the form that appears best calculated for reference, in order to preserve the facts thus collected." Lovell proposed that observations should be made for eight or ten years "in order to ascertain what changes, if any, have taken place, either in the mean temperature, the range of the thermometer, the course of the winds, or the weather" after settlement of the country.

Benjamin King (1797–1888) served as interim surgeon general of the Army after the death of Joseph Lovell in the fall of 1836. King served in this position for only a few months, but his actions were instrumental in formally establishing the Library of the Surgeon General's Office. He originally enlisted in the Army as a surgeon's mate on October 14, 1818, at the age of 21.

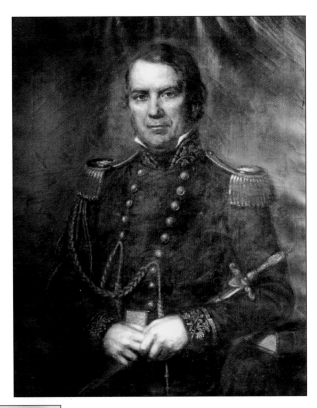

Interim Surgeon General Benjamin King submitted this estimate of expenses for the upcoming year 1837 to the secretary of war on November 12, 1836. The last line indicates an estimated cost of $150 for "Medical Books for office." This estimate marks the first time funding was requested specifically to purchase medical books that would remain in the Office of the Surgeon General rather than for shipment to medical officers and hospitals in the field. It also marks the beginning of the Library of the Surgeon General's Office, the institutional predecessor of the US National Library of Medicine. (Courtesy of the National Archives.)

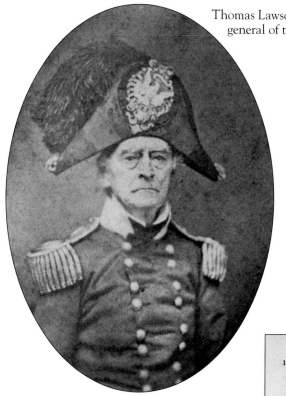

Thomas Lawson (1789–1861) was the second surgeon general of the Army, from 1836 to 1861.

METEOROLOGICAL REGISTER. — 12

[E]

PLACES OR OBSERVATION	Latitude	Mean Annual Temperature	Range of the Thermometer			Dec.	Jan.	Feb.	Mar.	April	May	June	July	Aug.	Sept.	Oct.	Nov.
West Point	41° 22'	51.66	101	-10	111	34.95	23.31	31.57	40.58	54.06	61.94	69.27	72.98	72.57	65.48	54.45	37.90
Fort Trumbull	41° 22'	53.10	88	0	88	42.24	27.15	34.73	42.35	53.15	59.00	67.35	73.16	71.39	66.75	58.16	41.85
							30.04			52.39			71.60			52.61	
							34.71			51.50			70.60			55.59	

[F]

| PLACES OR OBSERVATION | Latitude | Mean Annual Temperature | Range of the Thermometer | | | Dec. | Jan. | Feb. | Mar. | April | May | June | July | Aug. | Sept. | Oct. | Nov. |
|---|---|---|---|---|---|---|---|---|---|---|---|---|---|---|---|---|---|---|
| Atlantic | 43° 21' | 45.00 | 92 | -2 | 94 | 33.72 | 28.20 | 34.61 | 35.48 | 43.46 | 56.05 | 65.68 | 70.00 | 69.51 | 62.21 | 49.75 | 40.49 |
| Interior, remote from Lakes | 48° 10' | 40.15 | 65 | -22 | 117 | 29.17 | 17.35 | 23.94 | 33.96 | 46.64 | 61.15 | 73.68 | 76.62 | 75.59 | 59.88 | 52.20 | 38.03 |
| | | | | | | | 32.18 | | | 44.58 | | | 68.40 | | | 50.82 | |
| | | | | | | | 23.48 | | | 47.26 | | | 75.30 | | | 50.02 | |

Surgeon General Thomas Lawson prepared the *Meteorological Register for the Years 1826–1830*. Lawson continued Lovell's collection of meteorological observations, retaining his tabular format to display temperatures, prevailing winds, and sky conditions. The result was a two-volume set of meteorological registers that provided detailed climate data for the years 1822 to 1830.

U. S. Surgeon general's

STATISTICAL REPORT

ON THE

SICKNESS AND MORTALITY

IN THE

ARMY OF THE UNITED STATES.

COMPILED FROM THE RECORDS OF THE SURGEON GENERAL'S AND ADJUTANT
GENERAL'S OFFICES—EMBRACING A PERIOD OF TWENTY YEARS,
FROM JANUARY, 1819, TO JANUARY, 1839.

———

PREPARED UNDER THE DIRECTION OF

THOMAS LAWSON, M. D.

SURGEON GENERAL.

———

Published for the use of the Medical Officers of the Army of the United States.

———

ARMY MEDICAL LIBRARY
WASHINGTON, D. C., U. S. A.
298530

WASHINGTON:
PRINTED BY JACOB GIDEON, JR.
1840.

Surgeon General Lawson and his staff published the *Statistical Report on the Sickness and Mortality in the Army of the United States* in 1840.

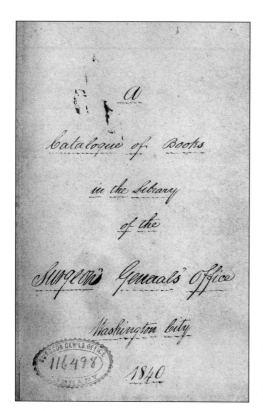

In 1840, an unidentified staff member of the Office of the Surgeon General compiled this catalog of the collection, which at the time included 134 books. The first page of the catalog is pictured below.

A

Abernethys Surgery	2 vol.
Adams on Epidemics	1 vol.
American Dispensatory	1 vol.
American Almanack	
American Medical Journal	25
Ainsworths Latin Dictionary	1 vol.
Art of preserving the feet	1 vol.
Army regulations	
Armstrong on Typhus fever	1 vol.
Andrals Med. Clinic	1 vol

Two

THE CIVIL WAR AND THE ERA OF JOHN SHAW BILLINGS

Surgeon General Thomas Lawson died on May 15, 1861, barely a month after the Civil War began with the Confederate bombardment of Fort Sumter in South Carolina. Clement A. Finley succeeded Lawson and held the position for less than a year before a young surgeon named William Alexander Hammond formally replaced him in April 1862. Despite his arrogance and abrasive personality—traits that would result in a court-martial and dismissal from the office after just two years—Hammond was an effective and visionary surgeon general, notable for recognizing the potential of the library and working to ensure its continued growth.

As medical officers struggled to cope with the devastating injuries they witnessed during the American Civil War, the need for new research dictated accelerated acquisitions by the library. The war presented opportunities for expansion of the Surgeon General's Office and for a new orientation of the library's collections. In 1862, the library moved from rented offices to the Riggs Bank Building in downtown Washington, DC, and Hammond established the Army Medical Museum as a corollary to the library to collect specimens and data for research in military surgery. Hammond also initiated a plan to create a comprehensive medical and surgical history of the Civil War, a plan that his successor, Joseph K. Barnes, would bring to fruition. The result was the monumental *Medical and Surgical History of the War of the Rebellion*, a multi-volume compilation of medical knowledge and illustrations unlike anything previously produced. Both the museum work and the *Medical and Surgical History* required varied and specialized medical knowledge heretofore unnecessary in the library. This need for unique medical information would continue after the war as the library began acquiring studies of yellow fever and cholera, which were regular scourges of Army personnel in scattered outposts.

The momentum of the war had shifted to favor the Union forces when Barnes succeeded Hammond as surgeon general in August 1864, but months of hard fighting still lay ahead. Barnes assigned Assistant Surgeon John Shaw Billings to the Surgeon General's Office in January 1865. The library was not a high priority within the medical department's operations, and its management was initially an informal addition to Billings's regular duties. Army surgeons and assistant surgeons routinely filled the administrative positions of the medical department. Like his fellow staff members, Billings was a physician, not a librarian. He did, however, possess a love of books and an appreciation for knowledge, which he avidly applied to the library. In satisfying

the library's growing needs and his own predilection for what should be collected, Billings oversaw expansion of the collection from 602 titles in 1865 to 2,887 titles in 1868.

Billings's devotion to and consummate concern for the library's development paid off when, around 1870, the library became his primary responsibility. By the end of 1871, with Surgeon General Barnes's concurrence, Billings embarked on a mission to transform the surgeon general's library into a national medical library holding every American medical publication possible. He envisioned it as a medical counterpart to the collection of the Library of Congress. The library relocated from cramped office shelving in the Riggs Bank Building to the roomier second floor of the remodeled Ford's Theatre on Tenth Street. After President Lincoln's assassination there in April 1865, contemporaries believed that the building was no longer appropriate as an entertainment venue, so it was converted to house several military offices. The Office of the Surgeon General eventually occupied the building to accommodate the growing Army Medical Museum and vastly expanded postwar administrative activities. The drive for acquisitions quickly expanded beyond American-produced works and increasingly included medical books and journals produced in all corners of the world. From this point onward, though it remained under the surgeon general of the US Army, the library publicized the availability of its resources to all medical professionals and researchers. This was the moment in the history of the library when its trajectory to become the largest repository of medical knowledge in the world began.

Billings soon recognized the need to provide a means for searching this vast ocean of knowledge by medical term or topic so that it could be accessed more effectively. To this end he conceived the *Index-Catalogue of the Library of the Surgeon-General's Office*, a published record of the library's holdings listed alphabetically according to medical subject and also by author name. It was an audacious project on an unprecedented scale. This was the first time anyone had attempted to index the entire range of medical subject matter. The first series of the *Index-Catalogue* comprised 16 volumes, which were successively published from 1880 to 1895.

Timely dissemination of new medical research is essential, but the meticulous indexing that went into the *Index-Catalogue* slowed its production. In response, Billings initiated the *Index Medicus*. Issued on a monthly basis, organized by subject, and with a cumulative year-end index, it was a use companion to the *Index-Catalogue*.

The library's constant flow of acquisitions continued unabated during the 30 years Billings oversaw the institution. In 1865, when he began work at the surgeon general's library, its 602 titles amounted to 2,282 individual volumes. When he retired from the library in 1895, the total collection of books, pamphlets, theses, and other volumes numbered 619,558. Upon leaving the military and the Army Medical Library in 1895, Billings applied his 30 years of library knowledge and experience to the organization and development of the New York Public Library. Beyond driving collection development, he conceived the original design of the New York Public Library's main building and was instrumental in persuading Andrew Carnegie to build branch libraries throughout New York City.

John Shaw Billings is renowned for his vision and realization of a national medical library, a repository of all available medical knowledge in the interest of advancing medical science. He is equally revered for conceiving the *Index-Catalogue* and *Index Medicus*, pioneering works in medical bibliography that revolutionized methods for the dissemination and use of medical knowledge.

—James Labosier

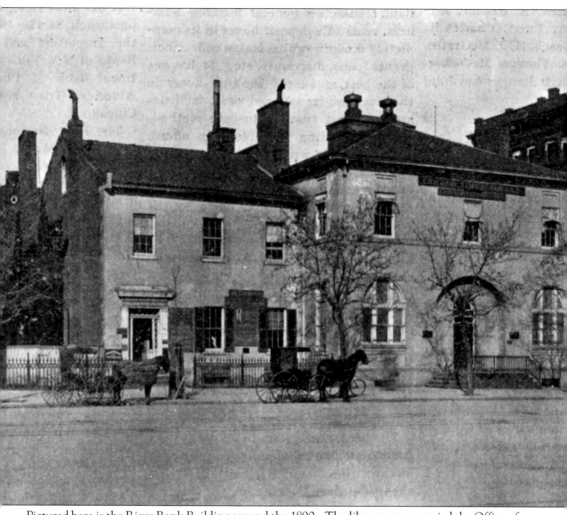

Pictured here is the Riggs Bank Building around the 1890s. The library accompanied the Office of the Surgeon General when, in 1862, that office moved into this building at Pennsylvania Avenue and Fifteenth Street NW, Washington, DC, one block from the White House. The front parlor on the first floor of the building on the left held the collection of the library from 1862 to 1866, before it moved to Ford's Theatre.

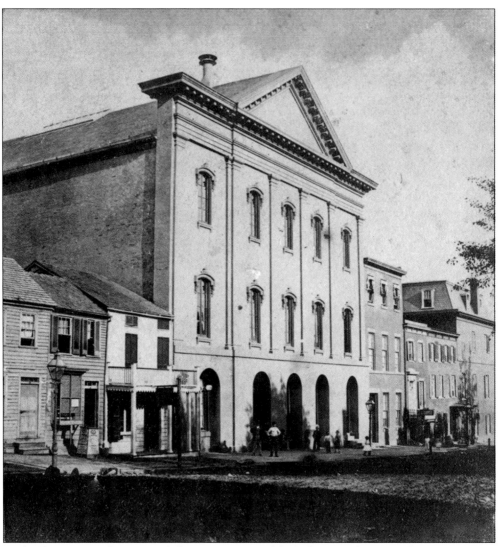

Ford's Theatre, seen here around the 1870s, was modified after President Lincoln's assassination to accommodate the Army Medical Library and Museum, which moved there in the fall of 1866. In preparation, the seating and balcony were removed and floors were installed to make a second and third level. The Record and Pension Division occupied the main level, the library occupied the second floor, and the Army Medical Museum occupied the third floor. Billings, his fellow officers, and the medical department's laboratory occupied space in an adjacent building. A small structure behind the theater served as a museum workshop.

Before assignment to the Surgeon General's Office in Washington, Assistant Surgeon John Shaw Billings (1838–1913) put his medical skills to work in the field with the Army of the Potomac at Chancellorsville and Gettysburg. Throughout the war, he was also stationed intermittently at military hospitals in Philadelphia and New York City. Billings is pictured at right around 1863. Below, Joseph K. Barnes is seen with a staff of surgeons at the Surgeon General's Office around 1865. From left to right are Assistant Surgeon George Otis, Surgeon William Canfield Spencer, Assistant Surgeon General Charles Henry Crane, Assistant Surgeon Alfred Alexander Woodhull, Surgeon General Joseph K. Barnes, Assistant Surgeon Edward Curtis, Assistant Surgeon John Shaw Billings, and Surgeon Joseph Janvier Woodward.

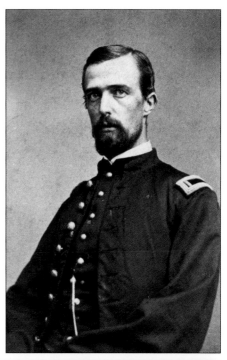

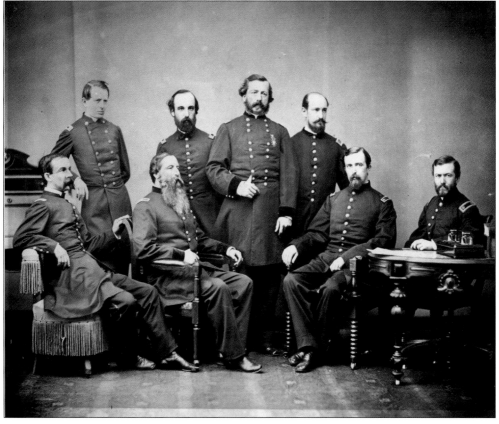

21

THE

MEDICAL AND SURGICAL HISTORY

OF THE

WAR OF THE REBELLION.
(1861-65.)

—◆—

PREPARED, IN ACCORDANCE WITH ACTS OF CONGRESS, UNDER THE DIRECTION OF

Surgeon General JOSEPH K. BARNES, United States Army.

—◆—

WASHINGTON:
GOVERNMENT PRINTING OFFICE.
1870.

LSGO

Otis, Barnes, and Woodward, along with fellow Army surgeons Charles Smart and David Lowe Huntington, compiled the exhaustive, multi-volume *Medical and Surgical History of the War of the Rebellion*. Published in parts from 1870 to 1888, this project influenced the growth of the library from an office reference collection to a formal library.

Library of the Surgeon General's Office
from George A. Otis
1865.
Aug. G. S. Vol.

BERNARDI SIEGFRIED ALBINI

EXPLICATIO

TABULARUM

ANATOMICARUM

BARTHOLOMAEI EUSTACHII,

ANATOMICI SUMMI.

Auctor recognovit, castigavit, auxit, denuo edidit.

LEIDAE.

Apud JOANNEM & HERMANNUM VERBEEK, Bibliop.

CIƆ IƆ C CLXI.

Pictured here are the title page and a detail of the library's inventory item no. 1, *The Explanation of Albinus's Anatomical Figures of the Human Skeleton and Muscles,* by Bernhard Siegfried Albinus, 1761. George A. Otis gave this book to the library in 1865, when he was working in the Surgeon General's Office, both in the library and in the Army Medical Museum, compiling the surgical history of the war. The library's collection had been formally inventoried in 1840, 1864, and 1865. When Billings conducted an inventory in 1867–1868, he initiated a numbering system. Each volume held in the collection was assigned a number. This system of enumeration was then continued, after number 6,984 (the last volume of the initial catalogue), for each volume acquired by the library and thereafter served as an accession number.

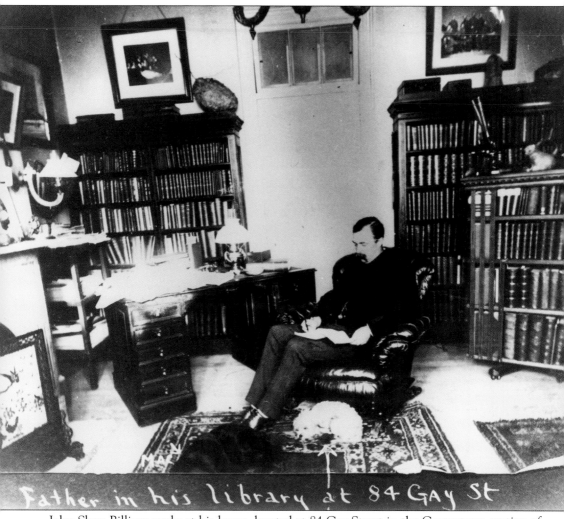

Father in his library at 84 Gay St

John Shaw Billings works at his home, located at 84 Gay Street in the Georgetown section of Washington, DC, around the 1870s. This address later became 3027 N Street NW. From 1874 onward, the drive to index the collection was secondary only to the accumulation of publications. Billings directed his staff in the indexing project and usually, after a full day at the library, brought home an armload of books and journals and continued indexing late into the evening.

May 13, 1872

Newark N. L.

Dr. A. W. Woodhull.

Dear Sir.

At the suggestion of your cousin Dr. A. A. Woodhull USA I write to ask your assistance in a matter which I have very much at heart and in which I hope you will take some interest. I am trying to form a great national Medical Library here — a work of great labor - which I am satisfied can only be done under Government Auspices. We have now about 18,000. vols - on our shelves in the fireproof building of the Army Med Museum. Catalogued and open to the Profession - and it is now on a proper basis as the Medical Section of the National or Congressional Library. I want to make it as complete as it can be made and the great difficulty of course is to get old pamphlets - and to complete our files of Journals. These I can only obtain by the personal aid of Physicians, who may be willing to part with them in consideration of the Object for which they are desired.

May I ask your aid in the matter? not merely in the way of personal contributions but that you will try to induce others who have old Pamphlets or Journals to deposit them here where they will form part of a monument that will last so long as the nation itself. All donations are marked with the name of the Donor and properly registered.

In this letter to a potential donor, written on May 13, 1872, John Shaw Billings explains his ambition for the library: "I am trying to form a great national Medical Library here—a work of great labor—which I am satisfied can only be done under government auspices. We have now about 18,000 vols—on our shelves in the fireproof building of the Army Med Museum. Catalogued and open to the profession—and it is now on a proper basis as the Medical Section of the National or Congressional Library. I want to make it as complete as it can be made and the great difficulty of course is to get old pamphlets—and to complete our files of journals."

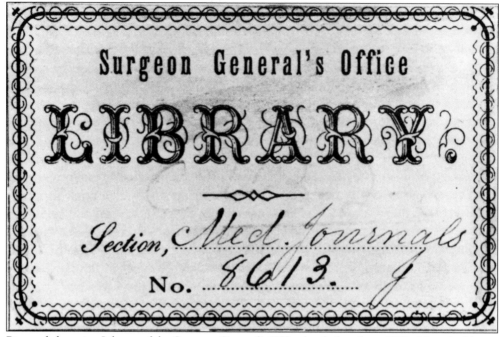

Pictured above is a Library of the Surgeon General's Office bookplate from 1872. After the library initiated a concentrated and comprehensive collection policy, new forms of record keeping were developed to track and identify acquisitions. This is an example of the earliest bookplate used for new acquisitions. Originally, library staff listed on a bookplate the donor of books given to the library along with the accession number, but later staff recorded the name of the donor only in the accession record books. Below are the rules of the Library of the Surgeon General's Office, printed on May 16, 1872. (Below, courtesy of the National Museum of Health and Medicine.)

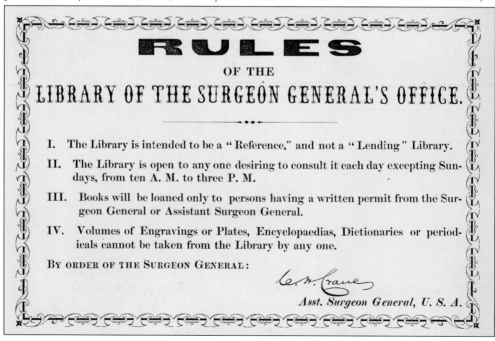

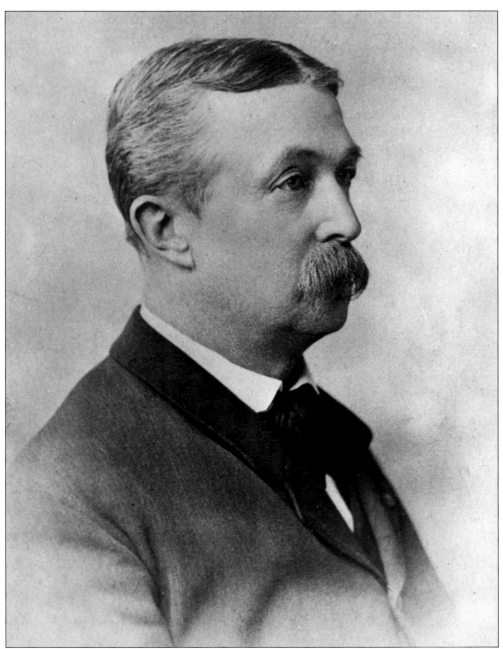

While he concentrated on building and indexing the Army Medical Library, John Shaw Billings attended to additional duties both mandatory and elective. During the 1870s, he oversaw the medical department's equipment and supply expenditures through its Disbursing Division. He also served on boards reviewing medical candidates and medical devices, and edited publications issued by the Surgeon General's Office. Additionally, he consulted with Johns Hopkins University on the construction of its hospital, based on his own design of the institution, and from 1879 to 1882, Billings was vice president of the National Board of Health, a Congressional agency created to prevent the spread of yellow fever and any other likely epidemics in the United States. This photograph is from the 1890s.

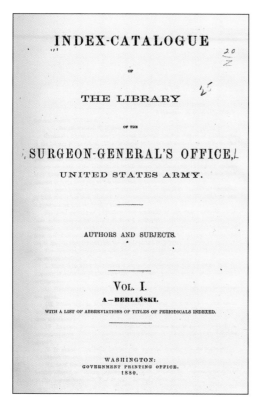

It took six years, from 1874 to 1880, before the first volume of the *Index-Catalogue's* first series was published. It was an 888-page publication covering the alphabetical range A to Berlinski. The remaining 15 volumes were published annually through 1895. By the time the first series was completed, however, the library's growth had greatly exceeded the material it described.

Produced monthly beginning in January 1879, the *Index Medicus* was issued by two successive publishers before 1895, both of whom incurred debts. Though it provided timely indexed subject listings of the most current medical literature, medical professionals only very slowly learned to appreciate the index's value. Up to 1895, it never had more than 500 subscribers.

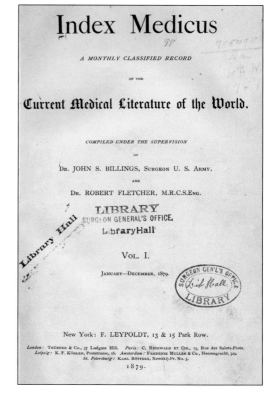

Library staff used this official emblem of the Library of the Surgeon General's Office on bookplates and stationery during the late 1800s.

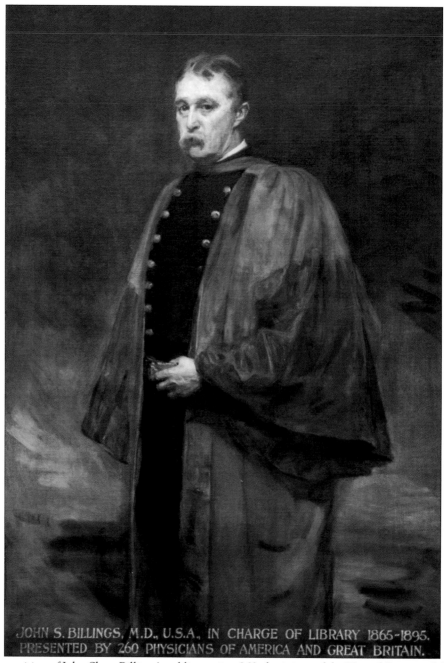

JOHN S. BILLINGS, M.D., U.S.A., IN CHARGE OF LIBRARY 1865-1895. PRESENTED BY 260 PHYSICIANS OF AMERICA AND GREAT BRITAIN.

In recognition of John Shaw Billings's public service, 260 physicians of the United States and Great Britain presented this portrait of him by Cecilia Beaux to the library at a testimonial banquet in Philadelphia on November 30, 1895. Born in Philadelphia, Beaux won many honors throughout her long career. She studied in Philadelphia under William Sartain and Thomas Eakins and in Paris in the Julien and Lazar schools. She painted, among other notables of the day, Henry James, the American-born British writer; Georges Benjamin Clemenceau, the French politician, physician, and journalist; and Désiré-Félicien-François-Joseph Mercier, a Belgian cardinal of the Roman Catholic Church and a noted scholar. (Courtesy of Stephen J. Greenberg.)

Three

THE "OLD RED BRICK"

The surgeon general's library moved into Ford's Theatre in 1866, but it was not until 1883 that Surgeon General Robert Murray consolidated the library and the Army Medical Museum into a single administrative institution, with John Shaw Billings as its director. By this time, the institutions could not move out of the building soon enough. Hastily constructed, Ford's Theatre was never suited to house a library or museum, despite its floors being subdivided with iron bookshelves and museum storage space. The rapidly expanding collections soon exceeded the available storage capacity, and their weight strained the floors nearly to the point of collapse, which they did in 1893, after the library and museum had moved out. Even before that terrible incident, museum and library staff worked in constant fear that a fire would destroy the collections. Dim lighting came from outdated gas and oil lamps, and the lack of air circulation created dank and stifling work spaces. For Surgeon General Murray, the library's location was untenable.

After several years of conceiving building designs and lobbying Congress for funds, Billings embarked on an effort to create a more suitable home for the library and the museum. To develop the overall concept of a new building, he referred to his own experiences of surveying Army hospital facilities during the Civil War and working with the trustees of the Johns Hopkins estate to design Johns Hopkins Hospital. Billings consulted with Adolf Cluss, the influential German architect, to shape the form and function of a new building. They designed an elegant and practical four-story structure consisting of two large wings—one for the Army Medical Museum and the other for the library—connected by a center building that housed offices and workrooms. Constructed of red brick, concrete, and iron, the entire building was effectively fireproof. As a precaution, each wing could be sealed off from the rest of the building to prevent fires from spreading. Light streamed through rows of large windows on the exterior walls, and heat from a steam boiler flowed throughout the air ducts of the building. In the rear courtyard, a small annex held the lavatories and the Army's pathological and biological laboratory.

In 1887, the Army Medical Museum and the library moved into their new location on the National Mall, at the intersection of Seventh Street and Independence Avenue, where the Hirshhorn Museum and Sculpture Garden is located today. For the first time, the library occupied a purpose-built facility, a grand and stately building its staff fondly called the "Old Red Brick."

The new building was a tremendous improvement over Ford's Theatre; however, it was not perfect. The abundant natural light coming through the windows did not reach the interior recesses, which made working in the book stacks difficult for the library staff. Electric lights were eventually installed but were not enough to remedy the lack of natural light. Librarians and clerks resorted to using flashlights to retrieve items from the stacks.

Within 10 years, library personnel realized that the growing pace of medical publishing and the library's acquisitions would soon exceed the available shelf space. Although Billings and Cluss designed the library's storage space to accommodate what they thought would be many years of growth, books and pamphlets were soon packed tightly into every corner of the spacious building, making retrievals difficult. By 1910, the roof leaked, the interior plumbing periodically flooded, and the plaster walls crumbled. The first renovation began in 1911, but Congress allocated only enough money to complete essential repairs, leaving minor structural problems to be addressed later.

In 1914, war erupted in Europe and spread across the world. The library staff felt the effects of the Great War. Many European medical publications that the library had been acquiring soon stopped arriving due to the German U-boat campaign against merchant ships in Atlantic shipping lanes. The United States entered the war in 1917, and when the US Department of War called men into service, this affected the library personnel, many of whom were Army clerks. Recognizing that the library could not function without much of its staff, the Army allowed library leadership to hire temporary employees, many of whom were women. This marked the first time that the library employed women in significant numbers, including Audrey Morgan, MD, and Loy McAfee, MD, both contract physicians with the US Army.

In 1917, library leadership saw the need for a medical history of the Great War, as it had done for the American Civil War with the *Medical and Surgical History of the War of the Rebellion*. The surgeon general created the History Division within the library to undertake the task of writing *The Medical Department of the United States Army in the World War*. Published over eight years from 1921 to 1929, this comprehensive 15-volume series covered subjects ranging from general surgery to hygiene, orthopedics to combat disorders, and hospitals to gas warfare.

The library and museum remained in the Old Red Brick for more than seven decades, but during World War II, the most valuable holdings of the library would find a new home.

—Anne Rothfeld, PhD

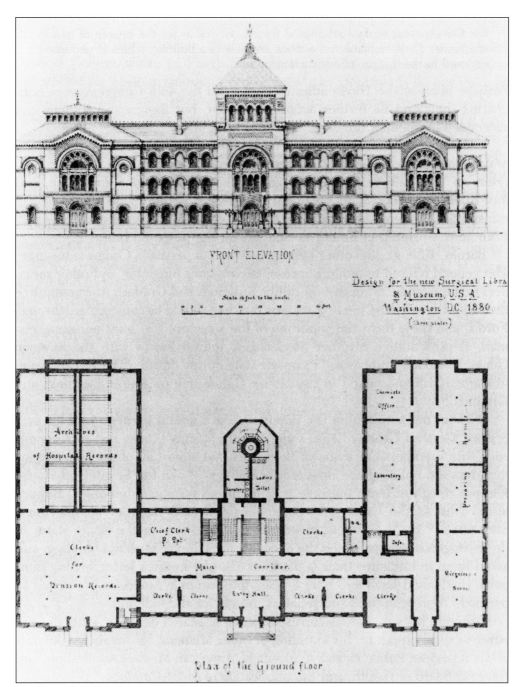

FRONT ELEVATION

Design for the new Surgical Library
& Museum, U.S.A.
Washington D.C. 1880
(three plates)

Plan of the Ground floor

By the mid-1870s, the Army Medical Museum and Library had outgrown the space at Ford's
Theatre. This is the first set of plans for the new library and museum building produced in 1880
and based upon Billings's ideas as translated into an architectural design by the firm Cluss &
Schulze—a four-story building with a functional U shape, with the left wing housing Library
Hall and the right wing housing the museum.

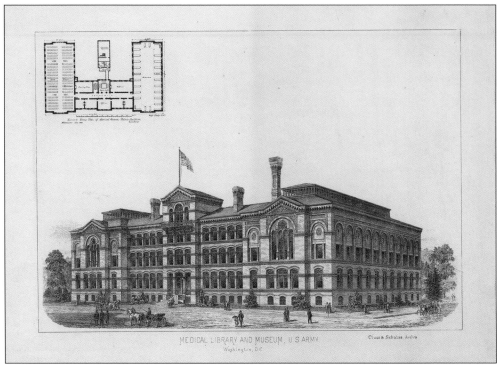

MEDICAL LIBRARY AND MUSEUM, U S ARMY
Washington, D.C.

Cluss & Schulze, Archt

Above is a later set of architectural plans for the new library and museum by Cluss & Schulze around 1885. Below is an exterior view of the Army Medical Museum and Library building completed in 1887. Working with Billings, German-born architect Adolf Cluss included his signature use of red brick in the design of the new building. In August 1887, the library began to move the collection into its newly constructed building on the National Mall, between the US Capitol and the Washington Monument. The left wing of the building was designated Library Hall.

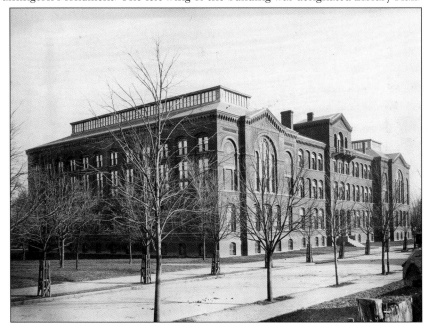

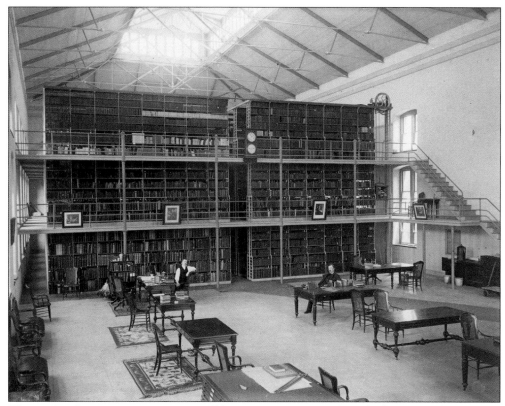

Thomas Washington Wise, manager of library operations, stands to the left of the desk as John Shaw Billings sits at a reference table in the new Library Hall in 1887. Billings involved himself with the smallest details of the library's planning, including the architectural designs for book shelving and retrieval. A dumbwaiter, or book lift, located at the right end of the stacks enabled staff to move books from one floor to another.

Staff of the Army Medical Library gather on the front steps of the Old Red Brick in the early 1910s. From left to right are (first row) Daniel S. Lamb, Walter Drew McCaw, Fielding H. Garrison, and Albert Allemann; (second row) Frank John Stockman, ? Fetter, David O. Floyd, Frederick W. Stone, Charles G. Toepper, Harry O. Hall, and ? Starkey; (third row) ? Coburn, Sam Brown, Benjamin King, Homer J. Councilor, ? McGraw, John J. Beardsley, and ? Martin.

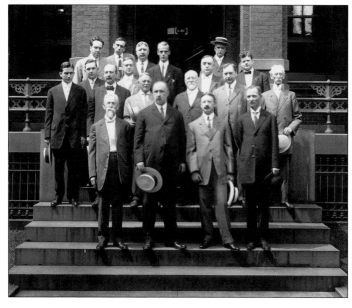

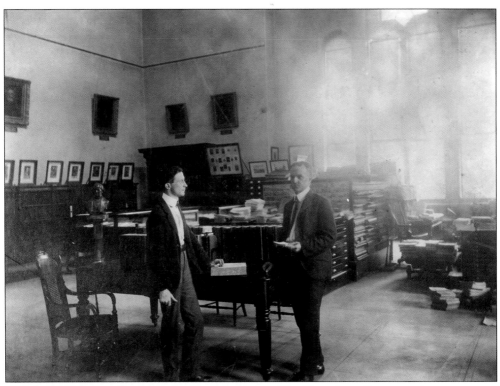

The library's reading room is bathed in light from a row of large windows in the 1910s.

The

MEDICAL DEPARTMENT
OF THE UNITED STATES ARMY
IN THE WORLD WAR

VOLUME I

THE
SURGEON GENERAL'S
OFFICE

PREPARED UNDER THE DIRECTION OF
MAJ. GEN. M. W. IRELAND, M. D.,
Surgeon General of the Army

By

COL. CHARLES LYNCH, M. C.
LIEUT. COL. FRANK W. WEED, M. C.
LOY McAFEE. A. M., M. D.

WASHINGTON :: GOVERNMENT PRINTING OFFICE :: 1923

Issued in 15 volumes, *The Medical Department of the United States Army in the World War* provided a comprehensive account of the Army Medical Department's experience during World War I. It covered subjects ranging from general surgery to hygiene, orthopedics to combat disorders, and hospitals to gas warfare.

Dr. Loy McAfee, pictured in 1917, worked at the library as a temporary employee during World War I. She became a compiler for the *Index-Catalogue* and developed special-topic bibliographies. The US Army granted permission to the library to hire women in large numbers to maintain operations during the war; many stayed on until their retirement.

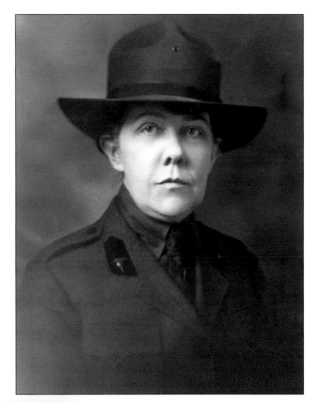

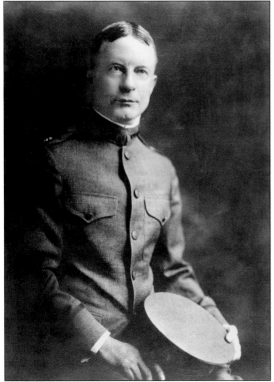

Fielding H. Garrison was a renowned medical historian, bibliographer, and librarian of medicine who became assistant librarian in 1899 and principal assistant librarian in 1912. Garrison joined the US Army Officers Reserve Corps as a major in 1917, rising to the ranks of lieutenant colonel in 1918 and colonel in 1920. Among historians of medicine, Garrison is known for writing the first comprehensive treatise on the history of medicine, as well as contributing to *The Medical Department of the United States Army in the World War*. Garrison is pictured around 1917.

ARMY MED. LIBRARY.

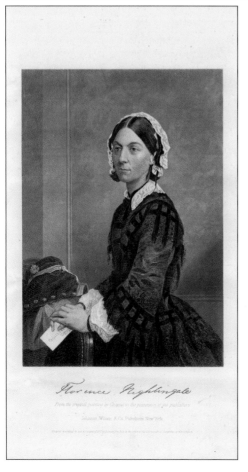

Florence Nightingale

Despite its structural issues, the Old Red Brick offered sufficient space for library staff to arrange numerous exhibitions of collection materials for interested patrons, like this one from 1935. The library carried on a tradition of such displays both at the library and elsewhere since at least the 1870s, when the Library of the Surgeon General's Office lent photographs for display at the International Exhibition of 1876. The exhibition depicted here was held in New York City at the Waldorf-Astoria Hotel during the annual meeting of the Association of Military Surgeons.

This engraving shows Florence Nightingale (1820–1910), English nurse, founder of professional nursing, savior of the British soldier in the Crimea and India, and decisive advocate for clean and orderly hospitals. Following Nightingale's death in 1910, library staff curated an exhibition featuring Nightingale's own publications and other works about her professional accomplishments. These materials and others associated with Nightingale, including letters written to and by her, reside in the collections of the library and are available to anyone who wishes to consult them for research and education.

The library celebrated 100 years of public service on November 16, 1936. Above, Sir Humphry Rolleston, the prominent English physician, addresses dignitaries and staff of the library at its centennial. Below, from left to right, Rolleston receives his official appointment as a consultant to the library from Charles Reynolds, surgeon general of the US Army from 1935 to 1939.

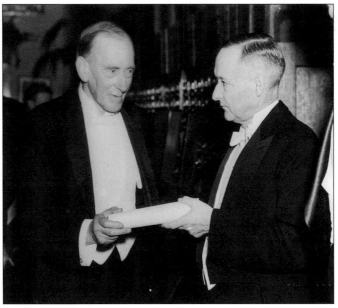

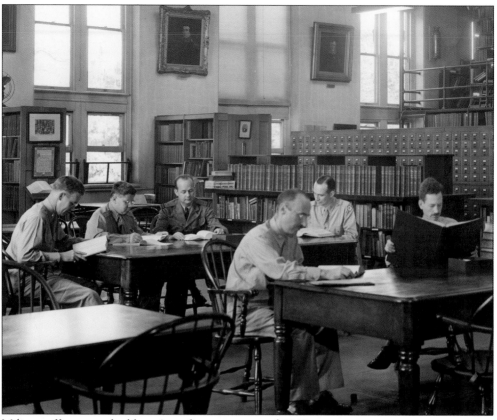

Military officers use the library's reading room around 1940.

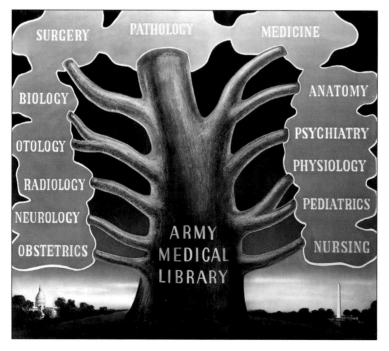

During the mid-1940s, the library produced advertisements like this one to encourage public use of its collections. This image depicts the library as the tree of medical knowledge, with branches representing the major subject fields collected by the institution. Note the location of the tree, and therefore the library on the National Mall between Capitol Hill and the Washington Monument.

This general
advertisement was
produced around
1945 by the library
to encourage public
use of its collections.

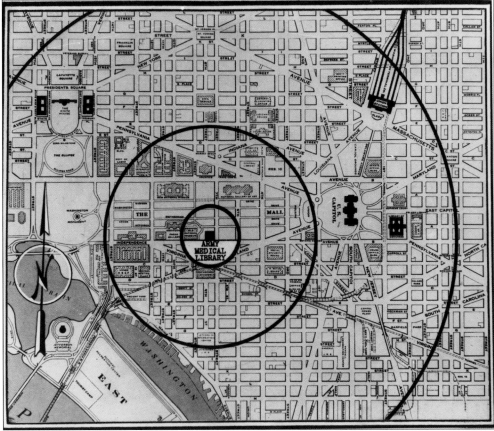

This street map of Washington, DC, shows the location of the Army Medical Library on the National Mall. It was produced by the library as part of its advertising campaign around 1945.

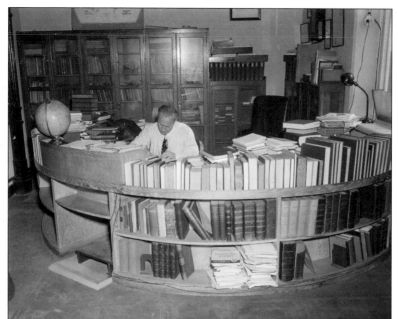

Claudius Meyer, principal librarian and editor of the *Index-Catalogue* from 1932 to 1954, works at his specially designed semicircular desk, complete with surrounding exterior shelves, in the late 1940s.

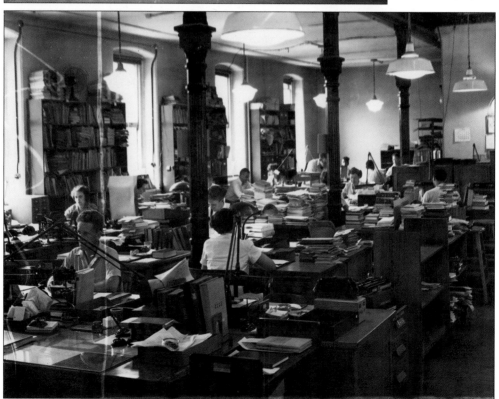

In many ways, the Acquisitions Division, shown here around 1950, was the center of the library's activities: identifying and obtaining the materials required for a comprehensive international collection. Challenging enough in peacetime, the world wars made the task infinitely more difficult, as normal acquisition channels were blocked.

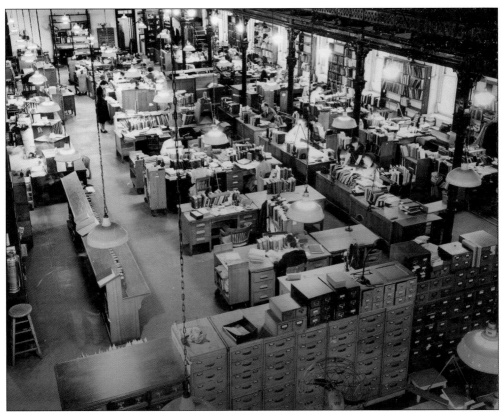

Not only did the library catalog its own materials in its Catalog Section, seen here around 1950, it also developed subject headings and indexing terms for the rest of the medical library community. (Courtesy of the National Museum of Health and Medicine.)

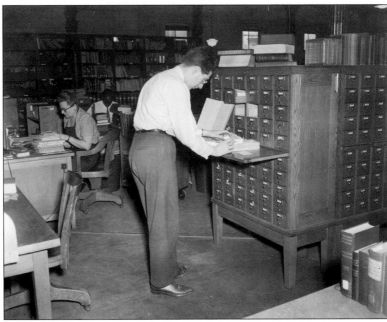

Cataloger Charles Colby uses the library's card catalog in the late 1940s. Before the advent of online public access catalogs, card catalog systems were state of the art.

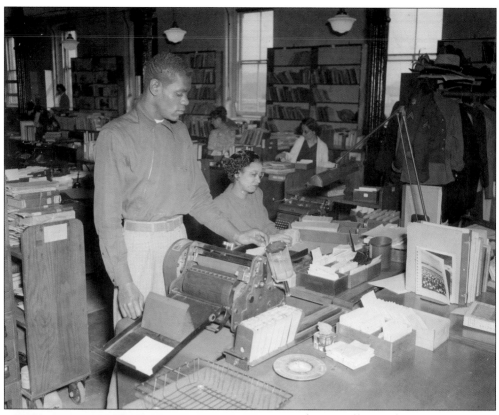

Library staff around 1948 use index cards, mimeograph machines, and manual typewriters to complete their work.

A staff member uses a Kodak Recordak microfilm camera to produce reduced-sized archival records around 1948. Microfilm provides access to materials for researchers, along with preservation of historical items.

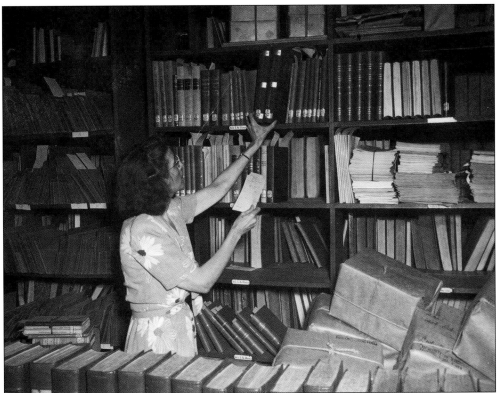

The process of acquiring serials (publications issued and numbered in parts) for the library involved sorting titles that arrived by mail and then integrating them into the collection, a process known as "accessioning," as seen above in the late 1940s. Below, library staff in the Bindery Section review materials in the collection. Binding involves putting together multiple issues of serials to conserve shelf space, improve durability, and assist reading by patrons.

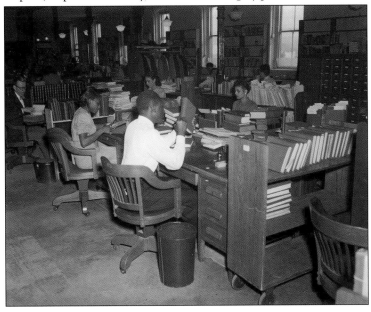

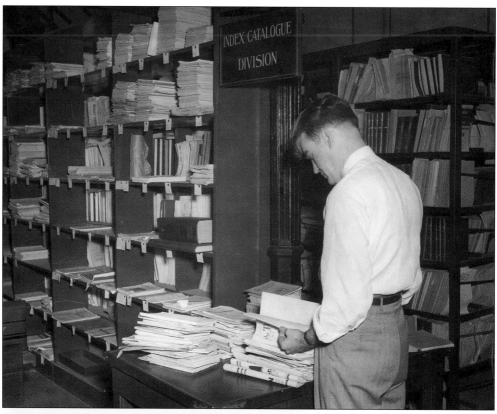

After books had been accessioned, library staff catalogued the material, adding authors, titles, and subjects, then described the books physically, by size, format, and length, so the content of these publications would be known to both staff and researchers. This work is seen above in the late 1940s. At left, also in the late 1940s, library staff catalog with hand-typed catalog cards and printed indexes that aided the compiling of bibliographic information. Some materials would be singled out for photoduplication for improved access. This would mean microfilming, if an entire volume was to be duplicated, or photostats (a predecessor to modern photocopies) if only a few pages needed to be copied.

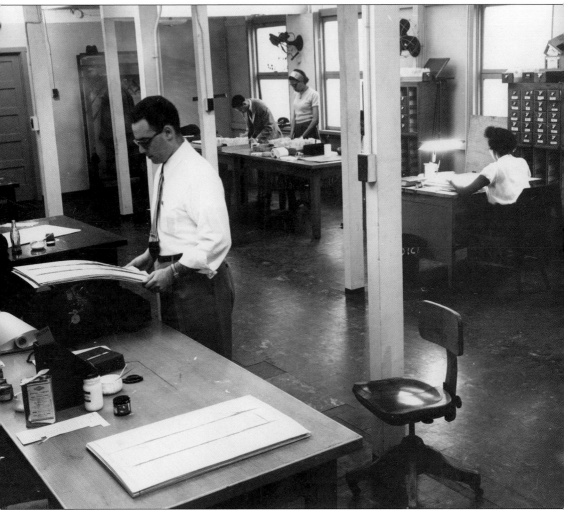

Harold Wolfe mounts boards for the *Current List of Medical Literature* in the late 1940s. Citations were typed on regular sheets of paper, which were then trimmed and pasted onto the boards. Paste jars and thinner are seen on the desk. The completed board was photographed on high-contrast lithographic film, which also reduced its size to a more standard page, and printed via high-speed offset lithography. This was a fast, efficient, and relatively inexpensive way to produce these time-sensitive volumes.

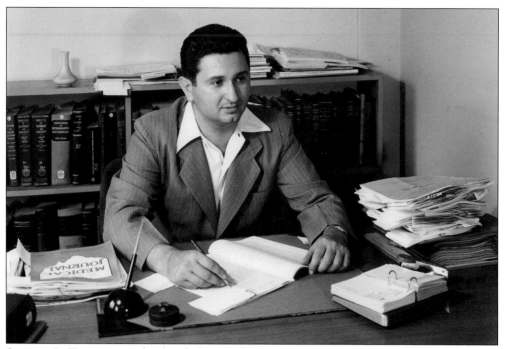

Seymour L. Taine, pictured at his desk around 1950, served as both editor of the *Current List of Medical Literature*—another Army Medical Library index designed to keep pace with the burgeoning flood of medical literature after 1941—and of the *Index Medicus*, during the years that saw the transformation of the Army Medical Library into the National Library of Medicine. He would later become director of the National Science Foundation's Federal Science Information Program and then head the World Health Organization's Office of Library and Health Literature Services.

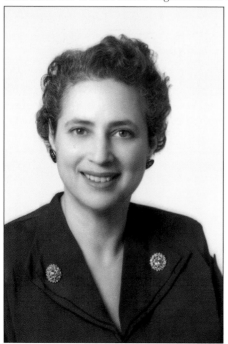

Estelle Brodman, PhD, pictured around 1950, studied at Cornell University and at Columbia University. She remained at Columbia after her graduation to become a member of the faculty of the Columbia School of Library Service. One of her students at Columbia was the future Armed Forces Medical Library director Frank B. Rogers, MD, who asked her to return with him to the library when he became director in 1949. Brodman became assistant librarian for reference services (head of the Reference Division), where she added a new level of professionalism to the library's activities. Foremost among her many publications is *The Development of Medical Bibliography*, published by the Medical Library Association in 1954. Brodman left the library in 1961 to become librarian and professor of medical history at the Washington University School of Medicine.

Staff of the offices of the director and librarian gather for a group photograph in the late 1940s or early 1950s. From left to right are (first row) Corinne Tucker; Aldine Mudd; Col. Joseph H. McNinch, MC (director); Scott Adams (acting librarian); Ethel M. Chase; and Alice Luethy; (second row) Martha Dietrich; Sarah L. Jenifer; Maj. Frank B. Rogers, MC (assistant director); Dorothy Joy Simken; and Mary J. Henke; (third row) Lee Dean; Joseph L. Tucker; Mary M. Koehler; and Sam W. Roberts.

Staff of the Catalog Division of the library are pictured in the late 1940s or early 1950s. From left to right are (first row) Lela M. Spanier, Winifred A. Johnson, M. Ruth MacDonald, Helen Turnbull, and Helen M. Cambell; (second row) Sadie E. Benjamin, Agnes M. Boush, Hans Mayer, Wanda D. Smith, Gertrude Sanders, Bessie M. Pennington, Justine Randers-Pehrson, and Helena M. Neal; (third row) Anna G. Ostroff, Ruth M. Manning, Ethel Elvove, Anna E. Dougherty, Gladys E. Hyland, Stella F. Schehl, Erna M. Webb, Emilie V. Wiggins, Valeta R. Richel, S. June Suzuki, and Evelyn E. Helms; (fourth row) Helen F. Feltovic, Dorothy J. Comins, Vera M. Payne, Helen C. MacNamee, Grover L. James, Ruth E. Howard, and Sarah I. Mills; (fifth row) Creola D. Wilson, Gladys B. Williams, William W. Perry, Milton Murayama, Juhan N. Raja, Portia J. Yergan, and Philip Holman; (sixth row) D.C. Papaloizou, Ralph Singer, Bela Belassa, Geneva T. Greene, Patrick J. Moloney, and James J. Gillis.

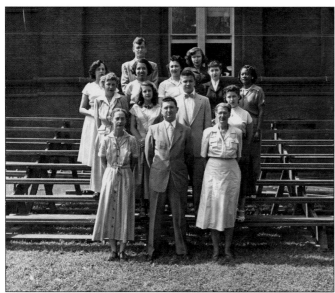

Staff of the Current List Section of the library are pictured sometime in the late 1940s or early 1950s. From left to right are (first row) Gertrude M. Butler, Seymour I. Taine, and Regina K. Plavsk; (second row) Frances E. Kelsey, Barbara F. Bytniewska, Constantine J. Gillespie, and Bertha A. O'Connell; (third row) Theresea T. Abbott, Bertha J. Cameron, Pauline C. Vivette, Thelma G. Charen, and Thelma Anders; (fourth row) Stanley Jablonski and Catherine E. Hagler.

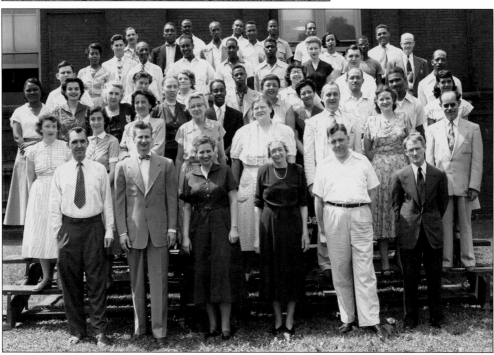

In the late 1950s, the library staff of the Reference Division gather for a photograph. From left to right are (first row) R.L. Carey, R.H. Eckenbach, Estelle Brodman, E.L. Frick, K.A. Baer, and C.A. Roos; (second row) D. Shamp, E. Koenig, S. Rafter, D. Bocker, N.R. Markham, A.H. Wagner, V. Britti, and L. Teitelbaum; (third row) S.V. Boyd, J. Chambers, F. Corrigan, E. Martinsen, W.E. Jones, C. Smith, M. Liles, R. Greene, H. Turner, and V. Lee; (fourth row) M. Gravitz, E. Wade, C. Duncan, E. Herndon, A. Caldwell, G. Slovensky, and W.E. Gibson; (fifth row) M. Toler, L. White, C. Drinkard, E. Twyman, A. Taylor, A.J. Stewart, S. Sands, and R.S. Cutter; (sixth row) A. Funkhouser, V. Jackson, M. Mack, D. Calloway, I. Stone, and H. Drew; (seventh row) F. Morris, F. Shiflet, O. Parham, A. Adams, and G. Queen.

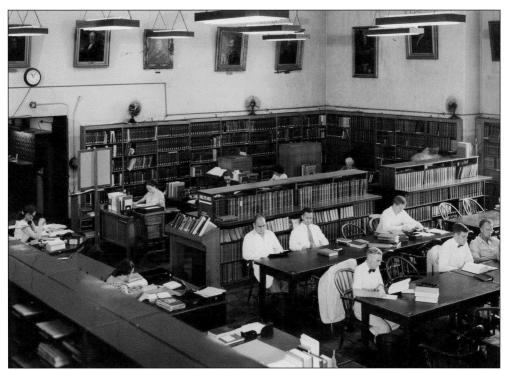

Above, patrons research various subjects in the reading room of the Army Medical Library in the Old Red Brick in the 1950s. Below, a group of distinguished consultants to the Army Medical Library gather for a lecture. (Above, courtesy of the National Museum of Health and Medicine.)

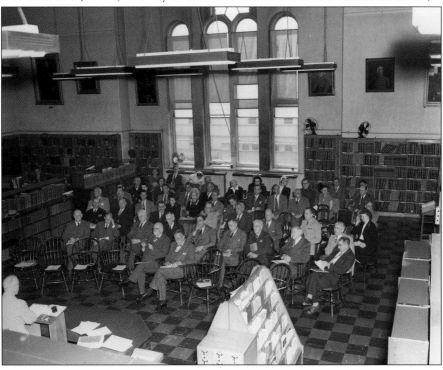

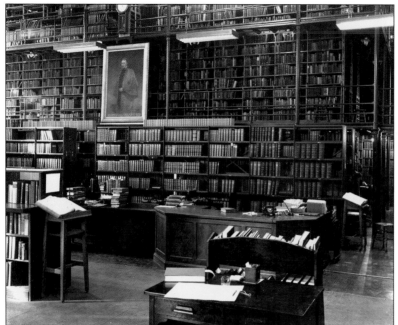

In this image of Library Hall in the 1950s, the portrait of John Shaw Billings by Cecilia Beaux hangs in the background. It remains in the collections of the library, and visitors can see it on display today at the National Library of Medicine.

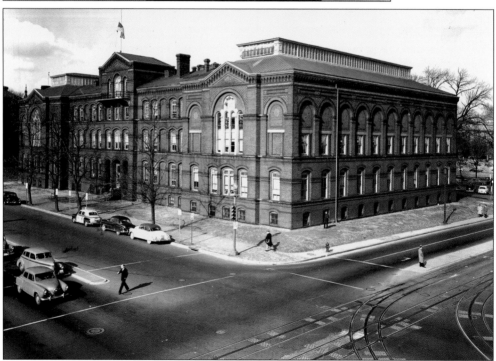

Dating from the 1950s, this is a view of the Old Red Brick in the decade prior to both its designation as a historic landmark and its later demolition. In 1964, the secretary of the interior approved a recommendation submitted by the National Survey of Historic Sites to recognize the building as a Registered National Historic Landmark. In October 1968, the doors were ceremoniously closed for the last time in preparation for its demolition and the construction of the Smithsonian's Hirshhorn Museum and Sculpture Garden, which stands in its place today.

Four

WORLD WAR II AND RELOCATION

During the long months between the Nazi conquest of Poland and the bombing of Pearl Harbor, one thing became clear: eventually, the United States would be drawn into World War II. But awareness is not preparedness.

By the autumn of 1939, Harold W. Jones had been librarian of the Army Medical Library for three years. A veteran surgeon, he had seen active service worldwide, but his experience did not extend to libraries. Initially, he felt ill at ease at his post, but he soon had a firm grasp of the library's problems.

The most pressing concern was space. The library was full, and the building was increasingly seen as a relic. Jones hounded the Army Medical Department, but his superiors would not spend money to renovate a building that might soon be replaced. In 1939, few suspected that America's entry into the war would create demand for off-site storage that would stave off the problem for a few years, while scuttling immediate plans for a new building.

After the attack on Pearl Harbor in December 1941, Jones received ever greater latitude in running the library. He reorganized staff, replacing the informal structure inherited from the days of Billings with three divisions: Index-Catalogue and Research; Acquisition, Finance, and Supply; and Custody and Loans; all were supported by a clerical department.

Some wartime difficulties were to be expected. Journals from Europe were hard to obtain; subscriptions dropped from 2,200 to 1,300. Jones resorted to alternative methods to keep library indexes comprehensive: borrowing journals from other libraries and obtaining needed copies through military intelligence services. Although the normal posting at the Army Medical Library was four years, Jones stayed on until the end of the war, the longest tenure of a librarian since Billings.

The library braced itself for new demands upon its resources. These increased slowly at first but eventually snowballed. The library instituted a translation service, and staff compiled specialized bibliographies for medical personnel in the field. Staff increased to meet the demand, from 46 in 1942 to 156 by the end of the war.

Some wartime measures bore unexpected fruit. The library was an early user of microfilm, then an emerging technology. At first, microfilm cleared space, but it was soon seized upon as a way to send text to multiple locations while keeping original materials available at the library. Later, microfilm was mobilized to create backups in case of an attack on Washington.

The safety of the library's most valuable holdings was a matter of increasing concern. A year before Pearl Harbor, Archibald MacLeish, librarian of Congress, wrote to Jones outlining "the question of the protection of the irreplaceable materials of scholarship, art, and public record in the hands of Federal Agencies in the District of Columbia against damage and destruction by bomb." MacLeish listed 14 institutions at risk, including the Army Medical Library. Jones responded promptly, estimating that the library would require 20,000 cubic feet of secure storage space. Thus began on August 25, 1942, one of the most remarkable episodes in the library's history: the first transfer of what would eventually be 952 boxes of rare materials (weighing 75 tons) from Washington to the Dudley P. Allen Memorial Library Building in Cleveland, Ohio. The space there was available at low cost, and the Midwest was considered "safe" from enemy attack. The material remained in Cleveland until the library's current home in Bethesda, Maryland, opened in 1962. In 1945, this material was designated as the History of Medicine Division, a name it has retained to this day.

Jones detailed Thomas Keys, who had worked at the Newberry Library in Chicago and the Mayo Clinic Library in Rochester, Minnesota, to run the Cleveland operation. Keys gathered a dedicated staff of clerks and library professionals to maintain the collection.

The move began in August 1942 and revealed the poor condition of many of the library's older books. Consistent with best practices of the era, Jones and Keys planned for extensive book repair and rebinding in Cleveland. This would keep the books as a working collection, available to scholars, and not just relics too fragile to touch. Original bindings would be repaired and retained if practicable, but since usability trumped all, many deteriorating bindings were discarded. By September 1943, the library had a bindery in Cleveland, soon considered to be one of the best in the country.

In Washington, Jones dealt with the pressures of running the wartime library. Demand was high, and staff struggled to keep pace. But Jones kept a long view. In 1943, he obtained private funding from the Rockefeller Foundation for a survey of the library. A team of librarians, under the auspices of the American Library Association and representing such institutions as Harvard, Columbia, Tulane, the New York Academy of Medicine, and the New York Public Library, inspected the library and issued their report in 1944.

The surveyors found much to criticize but few surprises. The building was too small and in need of extensive refurbishment. There were inconsistencies in the library's signature products, such as the *Index-Catalogue* and the *Index Medicus*. Large infusions of money and staff were needed, both unattainable in 1944. Jones knew that, and so did the surveyors. Significantly, the survey report refers to the Army Medical Library as "The National Medical Library," recognizing its role, if not its name. It was a name that Billings had first suggested in the 1870s.

By 1945, Jones was 68 years old and in poor health. He could not oversee a revamping of the library. He was finally allowed to retire; his successor was Leon Lloyd Gardner, another long-serving Army doctor with no background in libraries. Gardner proved a poor fit, and he soon left, to be replaced in 1946 by Joseph H. McNinch, who also lacked a library background but who knew where to begin. McNinch's copy of the survey report, still in the library's collection, bears the signed inscription, "In 1946–1949, this was my Bible."

—Stephen J. Greenberg, PhD

Harold W. Jones (1877–1958) led the Army Medical Library from 1936 to 1945.

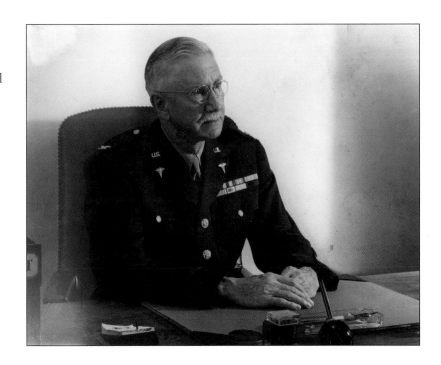

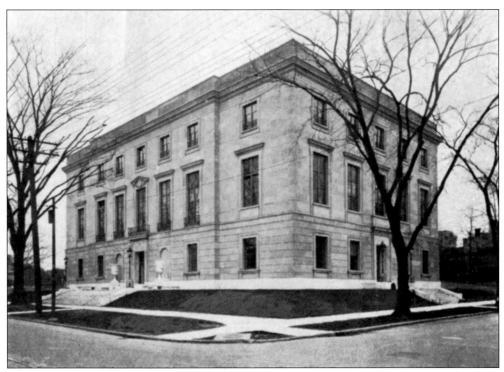

Owned by the Cleveland Medical Library Association, the Dudley P. Allen Memorial Library Building was home to the rare book collection of the Army Medical Library from 1942 to 1962.

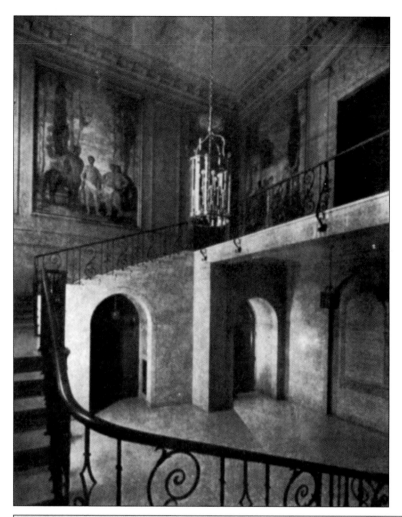

Ornate decor and artwork welcomed visitors to the Dudley P. Allen Memorial Library Building when it housed the rare book collection of the Army Medical Library.

★ ★ ARMY ★ ★
MEDICAL LIBRARY
Cleveland Branch

Library staff added bookplates like this to volumes moved to Cleveland during the war years. The bookplates did not change when the collection returned to the East Coast, so many volumes on the shelves of the current National Library of Medicine still bear Cleveland bookplates.

Staff of the Army Medical Library gather in the mid-1940s. Pictured are William J. Wilson, PhD (first row, second from left), chief of the History of Medicine Division of the library, and Dorothy Schullian (first row, third from left), who would become one of the most significant scholars and bibliographers in the history of the library.

Shown is the bindery area of the Army Medical Library in Cleveland. Modern scholars and lovers of books and libraries might decry the information lost with the discarded bindings, but standards and practices were different then. Among the highly trained staff who worked at the bindery and produced the best bindings of the day was Jean Eschmann, seen here. Eschmann was a master bookbinder from Switzerland.

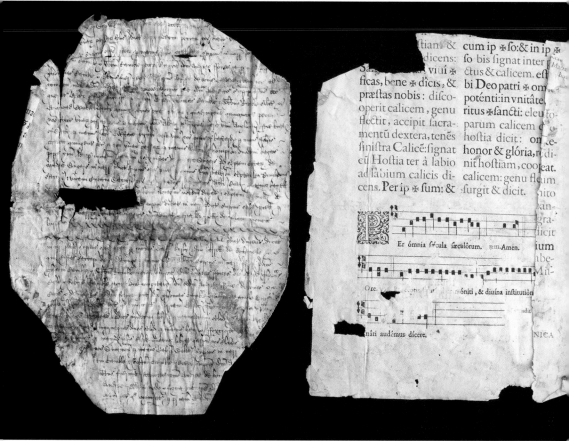

These are examples of the library's so-called "Bathtub Collection." Traditional bookbindings were padded out with "binder's waste"—bits and scraps of paper pressed into service inside of the binding, between leather and board. When the library removed old bindings in the Cleveland workshop, Dorothy Schullian assiduously collected the discarded material, took it home, and soaked it apart in her bathtub to get at the binder's waste. When the bits contained identifiable text she returned them to the library, where staff catalogued them as the Bathtub Collection. (Courtesy of Stephen J. Greenberg.)

An example of early European bookbinding awaits repair at the Army Medical Library in Cleveland sometime in the early 1940s. The inventory of the library's rare books, in preparation for the transfer to Cleveland, revealed many such deteriorated bindings. This led to Harold W. Jones establishing the bindery in Cleveland.

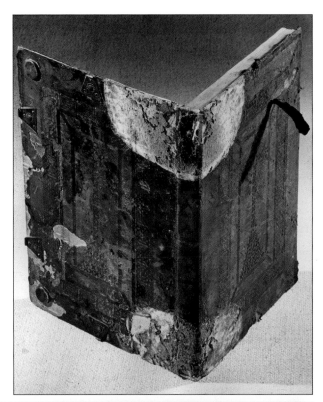

These are some of the books rebound in the Army Medical Library in Cleveland between 1943 and 1947. The style and details of the bindings varied according to the age of the book. Library staff rebound these 15th-century books in full morocco leather, a durable form of goatskin traditionally associated with fine bookbinding. (Courtesy of Stephen J. Greenberg.)

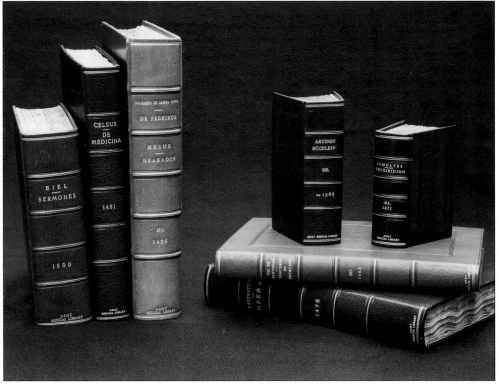

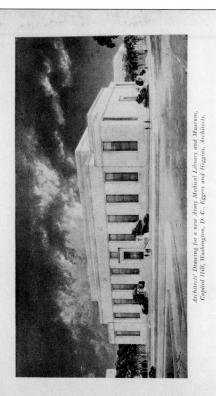

Architects' Drawing for a new Army Medical Library and Museum, Capitol Hill, Washington, D. C. Eggers and Higgins, Architects.

THE
National Medical Library

REPORT OF A SURVEY OF
THE ARMY MEDICAL LIBRARY

*Financed by the Rockefeller Foundation
and made under the auspices of
the American Library Association*

by

KEYES D. METCALF, *Harvard University*
JANET DOE, *New York Academy of Medicine*
THOMAS P. FLEMING, *Columbia University*
MARY LOUISE MARSHALL, *Tulane University
and the Orleans Parish Medical Society*
L. QUINCY MUMFORD, *New York Public
Library*
ANDREW D. OSBORN, *Harvard University*

AMERICAN LIBRARY ASSOCIATION
Chicago, 1944

Shown is the title page of the American Library Association report sponsored by Harold W. Jones in 1944. The facing page shows the proposed new home of the Army Medical Library near the Library of Congress on Capitol Hill, a project that was cancelled because of World War II.

Joseph H. McNinch's inscription appears in his copy of the 1944 American Library Association report on the Army Medical Library. Written on the flyleaf (blank page) of the book, the inscription reads, "In 1946–1949, this was my Bible." The volume is now part of the library's collection.

Five

A New Name and a New Home

During the sunny and warm afternoon of June 12, 1959, dignitaries and guests gathered on the campus of the National Institutes of Health in Bethesda to break ground for the new National Library of Medicine. Only a few years earlier, Senators Joseph Lister Hill and John F. Kennedy had introduced a bill to transfer the library to the US Public Health Service and rename it from the Armed Forces Medical Library, as it had been known since 1952, to the National Library of Medicine. President Dwight D. Eisenhower signed the bill into law on August 3, 1956, paving the way for the ground breaking in 1959 and the dedication of the new library building two and a half years later, on December 14, 1961.

However, the road to this new home was not an easy one. For nearly a decade after World War II, various committees, government agencies, and individuals debated how to fund a new library building, where to locate it, and whether to keep it within the US Army. Most agreed that the library should be transferred to a civilian agency so that it would not need to compete for military funding. Some suggested the Library of Congress. Others suggested the Department of Health, Education, and Welfare, which included the Public Health Service. Many argued for a site somewhere in Bethesda, near the National Naval Medical Center and the National Institutes of Health. Others proposed moving the library to Chicago, near the headquarters of the American Medical Association. Ultimately, with the support of many prominent individuals, including the surgeon Michael E. DeBakey, former library director Joseph H. McNinch, John Fulton, Chauncey D. Leake, and other leaders in medicine and government who held the library in high regard, the argument for Bethesda won the day. Its new location would be on the former Glenbrook public golf course at the south end of the campus of the National Institutes of Health.

Architects designed the building, situated on a knoll facing Wisconsin Avenue, to be a very modern and efficient new home for the library. The structure measured 276 feet by 192 feet, and its five levels provided 231,560 square feet of floor space and a quarter million linear feet of space for shelves, with an ultimate capacity of 1.5 million volumes. Planners expected that it could accommodate expansion for at least 25 years. It had plenty of electric light throughout and lots of elevators to facilitate movement of staff and materials. While book and journal storage occupied several floors, technical and photographic services had a large amount of space as well. These spaces would also soon house computer technology that would become essential to the library's mission.

The architecture of the building also exemplified the Cold War era in a number of ways. The lead architect, Walter H. Kilham Jr., later recalled that he had to give particular consideration to the effects of a potential atomic bomb blast. His plans therefore included reinforced concrete walls, small windows, and three underground levels for book stacks. Kilham also designed the library to have a secondary use as an air-raid shelter. For many years, the lower levels housed containers of food, medical kits, and other civil defense emergency supplies along with the books. And even the eye-catching, pagoda-like roof of the new building was in part a bomb-resistance feature, providing what Kilham described as a pressure-relief opening near the center that would protect the collection from bomb-blast shock waves. Kilham later commented that though many people viewed the unusual shape of the "dome" with misgivings at first, eventually it came to be "accepted and finally liked by practically everyone."

On the morning of December 14, 1961, dignitaries and guests gathered again on the campus of the National Institutes of Health, this time to dedicate the new building as the National Library of Medicine. Among them was Abraham Ribicoff, secretary of health, education, and welfare, who conveyed a message of congratulations from President John F. Kennedy:

> The dedication of the new National Library of Medicine perpetuates a distinguished history extending back to the early days of our nation. This enterprise has my congratulations and best wishes for a new era of outstanding service to medical research and the dissemination of medical knowledge throughout America and around the world.

During the spring of the following year, movers relocated the collection of the library—totaling 65,000 linear feet of materials—from the Old Red Brick to the new one in Bethesda. Movers also transported to the new building the 35,000 volumes of the Historical and Rare Books Collection that had been housed in Cleveland since World War II. The new National Library of Medicine opened its doors to the public on April 14, 1962, under the direction of Col. Frank B. Rogers, MD (1914–1987), the last active-duty Army officer to serve as director as the library transitioned to a civilian agency.

Sometime during or after the demolition of the Old Red Brick in February 1969, staff collected bricks from the site for keepsakes and to offer as retirement gifts to colleagues and friends of the institutions. Since that time, many of these bricks have been returned to both the library, at its current home on the campus of the National Institutes of Health, and the museum, at its current home in Silver Spring, Maryland, as part of materials donated to the institutions by former staff, or by medical and scientific leaders who received bricks as tokens of appreciation. So while the Old Red Brick is gone, pieces of it remain to help historians, librarians, and others remember the history of the library and the museum and the place they once occupied on the National Mall.

—Jeffrey S. Reznick, PhD, and Susan L. Speaker, PhD

Known as honorary consultants to the library, this volunteer group of physicians, medical educators, and librarians advised the library's leadership from 1945 to 1953. Pictured around 1950 are, from left to right, (first row) Col. Joseph H. McNinch, MD, director, Army Medical Library 1946–1949; Wilburt C. Davison, MD, founding dean of the School of Medicine of Duke University and its first chair of pediatrics; Morris Fishbein, MD, editor of the *Journal of the American Medical Association* from 1924 to 1950; and Chauncey D. Leake, MD, pharmacologist, vice president, and dean of the University of Texas medical school; (second row) Edward H. Cushing, MD, clinical professor of medicine at Western Reserve University; Adm. George W. Calver, MD, attending physician to the US Congress from 1928 to 1966; Robert M. Stecher, MD, rheumatologist, medical library and museum advocate, and rare book collector; Thomas E. Keys, MD, assistant librarian at the Army Medical Library from 1942 to 1946 and subsequently librarian of the Mayo Clinic Library; Michael E. DeBakey, MD, vascular surgeon and chair of surgery at Baylor Medical College; and Maj. Frank B. Rogers, MD, director of the Army Medical Library from 1949 to 1963.

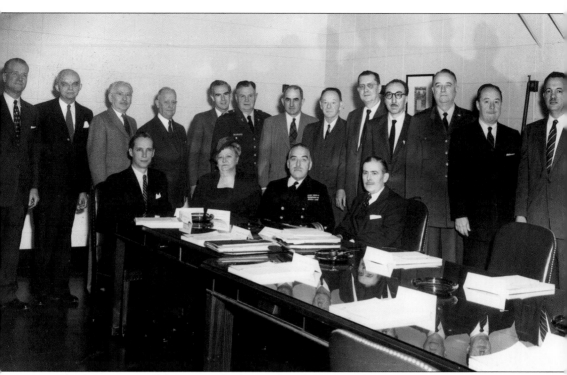

The first meeting of the National Library of Medicine Board of Regents took place on March 20, 1957, at the Army Medical Museum in the Old Red Brick. Attending the meeting were, from left to right, (seated) Leroy E. Burney, MD, US surgeon general; Mary Louise Marshall, director of the Medical Library of Tulane University; Rear Adm. B.W. Hogan, surgeon general, US Navy; and L. Quincy Mumford, 11th librarian of Congress; (standing) Ernest Volwiler, PhD; Jean A. Curran, MD; Benjamin Spector, MD; William S. Middleton, MD; John T. Wilson, MD; Maj. Gen. Silas B. Hays, MD, US Army surgeon general; Basil G. Bibby, DMD, PhD; Worth B. Daniels, MD; Champ Lyons, MD; Michael E. DeBakey, MD; Maj. Gen. D.C. Ogle, MD, surgeon general, US Air Force; Thomas Francis Jr., MD; and Lt. Col. Frank B. Rogers, MD. During the meeting, one of the primary agenda items was to determine a new permanent location of the library. Those present discussed the pros and cons of approximately 10 locations. As part of a follow-up meeting on April 29, 1957, most of the regents took a bus tour of several of the locations before ultimately deciding, with the encouragement of Michael DeBakey, to house the library on the campus of the National Institutes of Health in Bethesda.

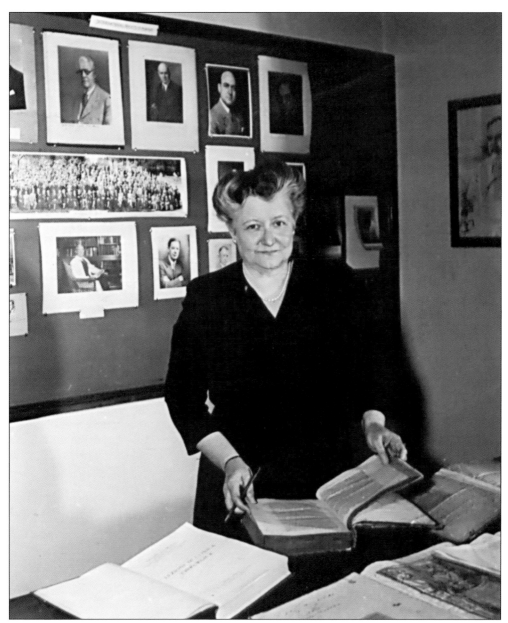

Mary Louise Marshall, professor of medical bibliography, Tulane School of Medicine, served on the survey committee on the future of the Army Medical Library organized in 1943 by Harold W. Jones. Subsequently, library director Frank B. Rogers, MD, appointed her to the library's first board of regents. Marshall was the only woman and the only medical librarian to serve on that important body, which determined the new location of the library on the campus of the National Institutes of Health in Bethesda. Marshall was an expert in library classification, the system of arranging materials to allow them to be stored, retrieved, and used by patrons. She successfully chaired committees that produced the Army Medical Library's own classification scheme, the precursor of the current NLM Classification, the standard for medical libraries around the world. Marshall is pictured here around 1945. (Courtesy of the Rudolph Matas Library of the Health Sciences, Tulane University.)

Dignitaries and guests gather on the warm and sunny afternoon of June 12, 1959, to witness the ground breaking for the new National Library of Medicine on the campus of the National Institutes of Health. It was only a few years earlier that legislation proposed the transfer of the library, then known as the Armed Forces Medical Library, to the US Public Health Service and the renaming of it to the National Library of Medicine. President Eisenhower signed the bill into law on August 3, 1956, paving the way for the ground breaking in 1959 and the dedication of the new library building two years later, on December 14, 1961.

Dignitaries are pictured on the speaker's platform during the ground-breaking ceremony of the new National Library of Medicine building on June 12, 1959. From left to right are Arthur S. Flemming, secretary, US Department of Health, Education, and Welfare; Michael E. DeBakey, MD; Leroy E. Burney, MD, US surgeon general; Champ Lyons, chairman of the library's board of regents; and Melvin R. Laird, a congressman from Wisconsin.

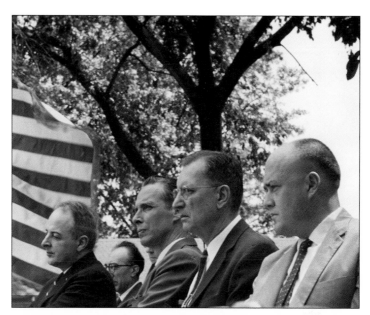

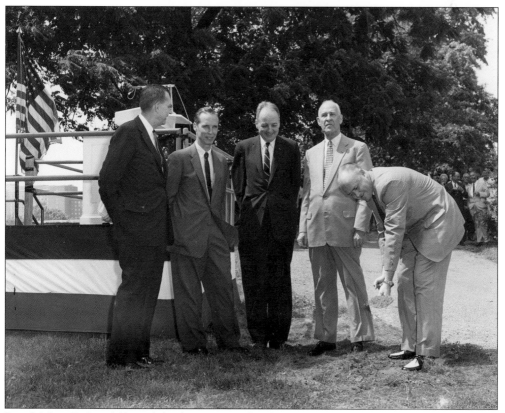

Rep. Melvin R. Laird (far right) takes a turn at breaking ground for the new National Library of Medicine building on June 12, 1959. With him are, from left to right, Champ Lyons, chair of the library's board of regents; Leroy E. Burney, MD, US surgeon general; Arthur S. Flemming, secretary, US Department of Health, Education, and Welfare; and Sen. Joseph Lister Hill of Alabama.

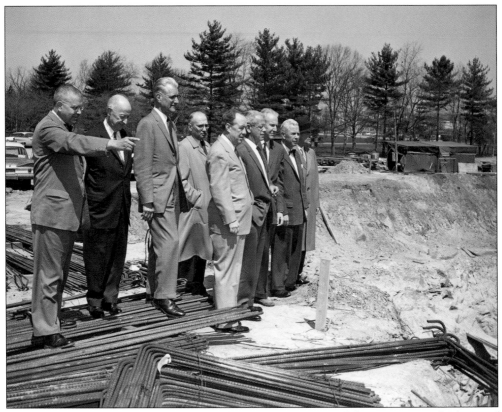

The board of regents of the library visits the construction site of the new National Library of Medicine around 1960.

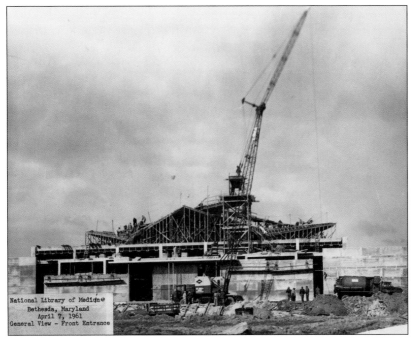

National Library of Medicine
Bethesda, Maryland
April 7, 1961
General View - Front Entrance

The front entrance of the new library building takes shape in this April 7, 1961, photograph.

Workers pour concrete into the rib reinforcements of the roof of the new library building on April 7, 1961.

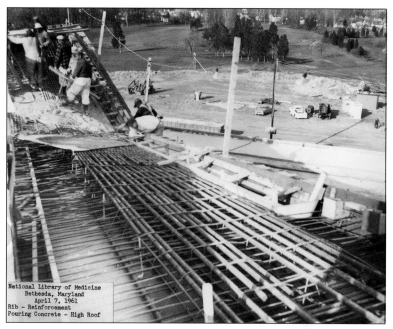

National Library of Medicine
Bethesda, Maryland
April 7, 1961
Rib – Reinforcement
Pouring Concrete – High Roof

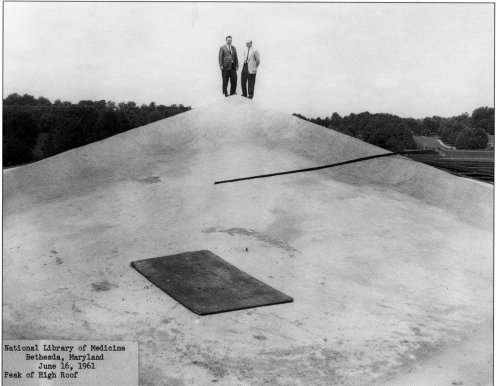

National Library of Medicine
Bethesda, Maryland
June 16, 1961
Peak of High Roof

Two men inspect the peak of the eye-catching, pagoda-like roof of the new library building on June 16, 1961. The roof was in part a bomb-resistance feature, providing what its architect described as a pressure-relief opening near the center that would protect the collection from bomb-blast shock waves.

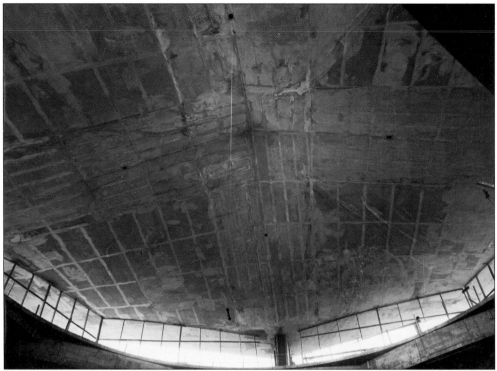

This mid-1961 interior view shows the roof before final plastering and painting, looking up from the library's rotunda.

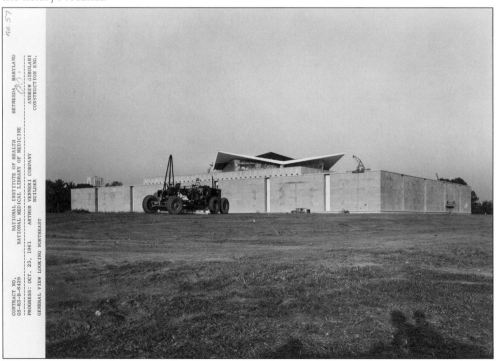

The new library building nears completion on October 25, 1961.

The cornerstone of the new National Library of Medicine building, located at the northeast corner, bears the inscription: "United States of America, Dwight D. Eisenhower, President, 1959." (Courtesy of Stephen J. Greenberg.)

Chiseling three designs in the lobby of the new library, artist Paul Jennewein creates a likeness of John Shaw Billings, the first director of the library, in late 1961. On the left, behind Jennewein, is a likeness of Fielding H. Garrison, MD, principal assistant librarian from 1912 to 1917, and on the right, adjacent to Billings, is Robert Fletcher, MD, principal assistant librarian from 1876 to 1912.

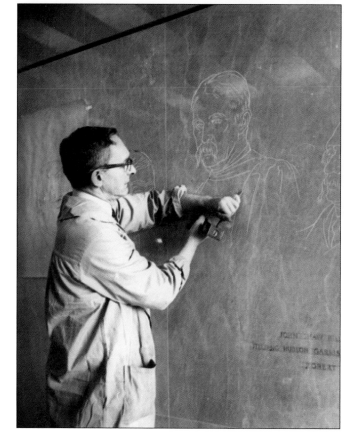

The new library awaits visitors and staff. Design features included a gleaming lobby (above) and state-of-the-art book stacks and workspaces (below).

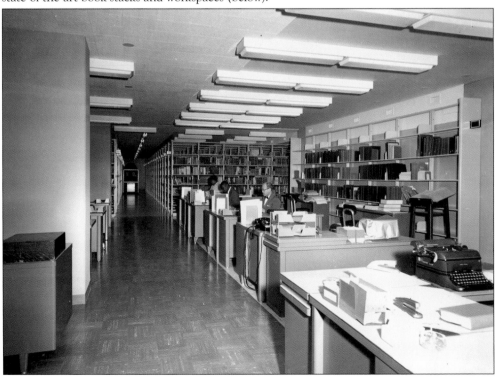

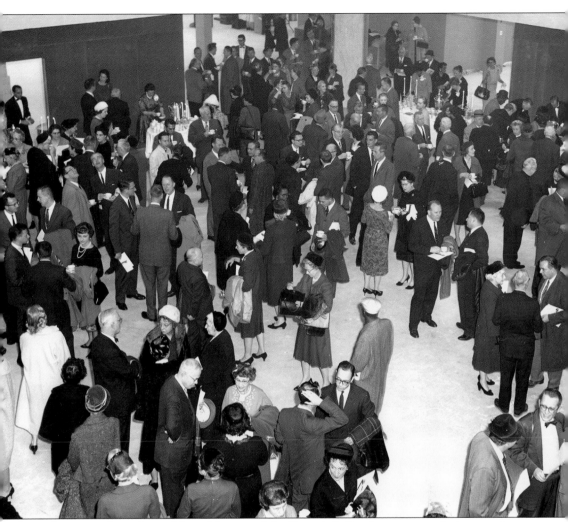

Invited guests and members of the public attend the library's dedication ceremony in its rotunda on December 14, 1961.

Sen. Joseph Lister Hill speaks at the podium at the dedication ceremony. A longtime advocate for health legislation, Hill co-sponsored the 1956 National Library of Medicine Act.

Worth B. Daniels, MD, the first chair of the library's board of regents, serves as the master of ceremonies at the dedication. In his remarks, Daniels quoted from a letter sent by President Kennedy to the leadership of the library, reproduced here, in which Kennedy acknowledged the dedication of the new National Library of Medicine and offered his "congratulations and best wishes for a new era of outstanding service to medical research and the dissemination of medical knowledge throughout America and around the world." During his tenure as senator from Massachusetts (1953–1960), Kennedy co-sponsored with Sen. Joseph Lister Hill a bill that transferred the library, then known as the Armed Forces Medical Library, to the US Public Health Service and named it the National Library of Medicine. President Eisenhower signed the bill into law on August 3, 1956.

THE WHITE HOUSE
WASHINGTON

The dedication of the new National Library of Medicine perpetuates a distinguished history extending back to the early days of our Nation. This enterprise has my congratulations and best wishes for a new era of outstanding service to medical research and the dissemination of medical knowledge throughout America and around the world.

John F. Kennedy

During the summer of 1963, President Kennedy addressed members of the International Congress on Medical Librarianship on the south lawn of the White House. Kennedy described how advancements in science and medicine create a greater need for the distribution of knowledge within the medical profession, and how medical librarians are instrumental in that distribution. He stated further, "We are proud of those who work in [the National Library of Medicine] and of the other libraries across the country." Members of the Congress on Medical Librarianship visited the new National Library of Medicine on June 18, 1963.

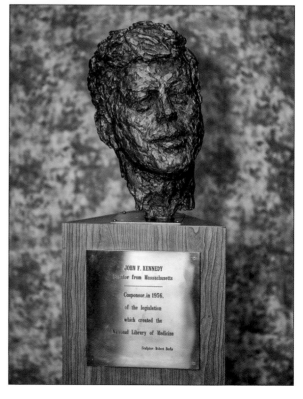

This bust of John F. Kennedy by Robert Berks is located in the main entranceway of the library today. It is a replica of the large bust located in the grand foyer of the Kennedy Center for the Performing Arts in Washington, DC. (Courtesy of Stephen J. Greenberg.)

On May 11, 1962, library staff participate in the planting of the library's "Tree of Hippocrates." Shortly after the new library opened its doors to the public, dignitaries gathered there again to honor the internationally recognized role of the institution as a steward of medical history. Near the library, they planted a cutting of an Oriental plane tree descended from the original Tree of Hippocrates on the island of Kos in Greece, under which, according to legend, Hippocrates taught a new kind of medicine to eager students in the 5th century BCE. Pictured here taking his turn at planting the tree is John B. Blake, PhD, chief of the History of Medicine Division of the library. Blake supervised the return of the library's History of Medicine collection from Cleveland to the new library building in Bethesda. Lloyd's of London insured the collection for $6 million, and Pinkerton guards escorted it at every turn.

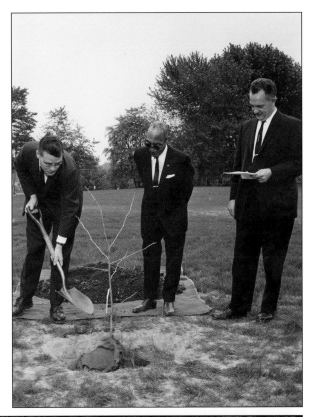

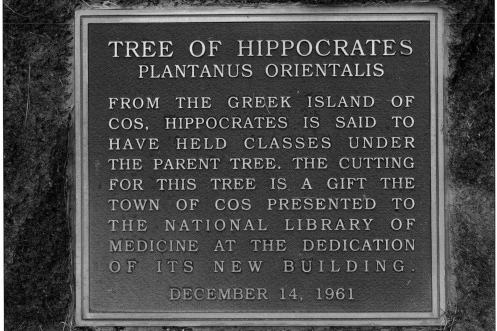

This plaque next to the library's Tree of Hippocrates explained the historical significance of the tree. (Courtesy of Stephen J. Greenberg.)

A medical specialist examines the health of the recently planted Tree of Hippocrates in May 1962.

The library's new Tree of Hippocrates was planted on April 25, 2014. The original tree lasted for many years until it succumbed to a fungal disease. Years of effort and research led to obtaining a clone of the tree, pictured at right, which dignitaries and guests of the library planted in the spring of 2014. Pictured below is the plaque next to the new tree. (Both, courtesy of Stephen J. Greenberg.)

TREE OF HIPPOCRATES
PLATANUS ORIENTALIS
FROM THE GREEK ISLAND OF COS, HIPPOCRATES IS SAID TO HAVE HELD CLASSES UNDER THE PARENT TREE. THE GIFT TREE WAS PRESENTED BY THE TOWN OF COS TO THE NATIONAL LIBRARY OF MEDICINE AT THE DEDICATION OF ITS NEW BUILDING ON DECEMBER 14, 1961.

THIS REPLACEMENT TREE, CLONED FROM THE GIFT TREE, WAS PLANTED ON APRIL 25, 2014

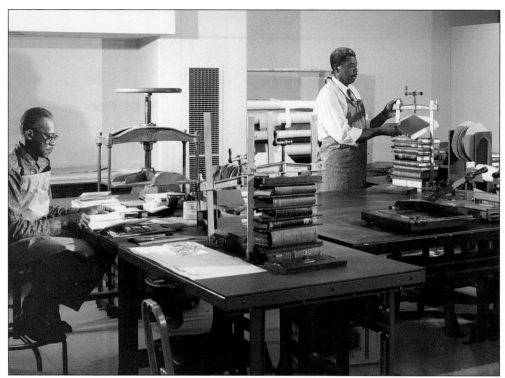

Above, bookbinders Holman (left) and Kinslow carefully handle collection items in the Bookbinding Section of the library around 1963. Below, reference librarians Richardson, Green, White, and Coleman are prepared to serve patrons in the Inter-library Loan Division.

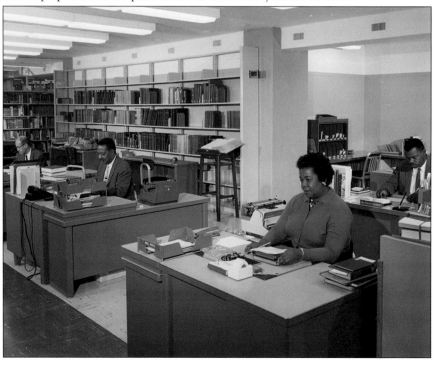

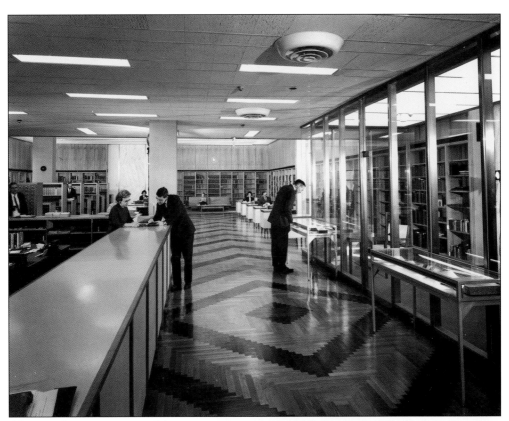

Above is the entranceway of the History of Medicine Division of the library around 1963. At right, a patron in the central rotunda area of the library uses the card catalog. Featured along the walls is the permanent ceramic mural created by Frans Wildenhain, a Bauhaus-trained German potter and sculptor, around 1963. This 208-foot-long frieze was composed of more than 900 individual pieces of freely designed ceramic and fused glass and mounted on four 52-foot walls. The mural is abstract and was originally conceived (in Wildenhain's words) "as a sort of wedding of medical and architectural motifs" but revised to "take the images off the earth," as it were, and "to send them flying around the room," thus representing the forms or impressions these subjects took in Wildenhain's mind.

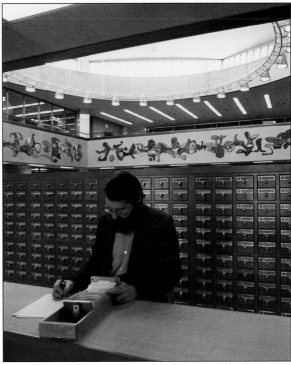

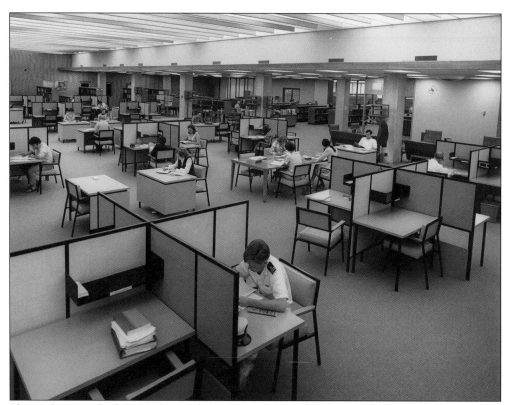

Shown here in the late 1960s are the reading rooms of the library. Above, patrons consult collection materials in the main reading room of the library. Below, librarians Dorothy Hanks and Sheldon Kotzin are at the reference desk in the reading room of the library's History of Medicine Division.

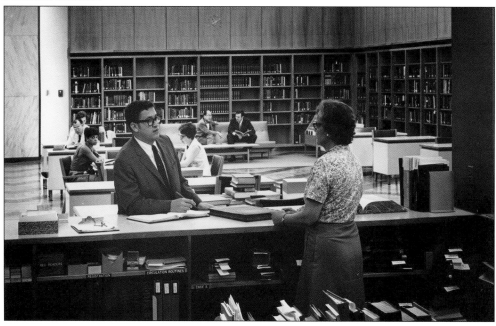

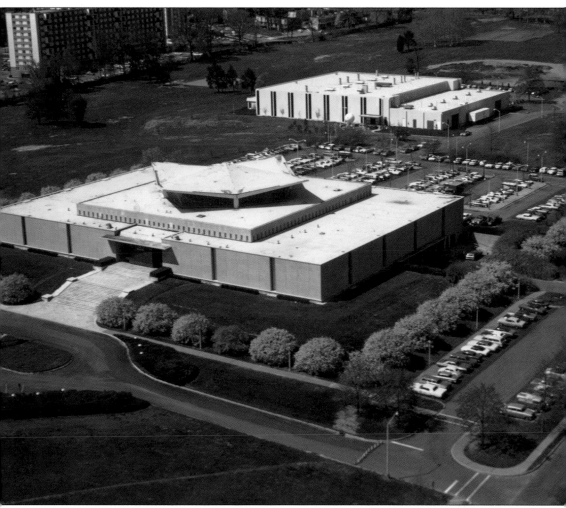

This aerial view of the library from around 1968 shows National Institutes of Health Building No. 41 in the background, and beyond it, apartment buildings in Bethesda. Upon its completion in 1969, Building No. 41 housed laboratories for the study of cancer. The building remains in use today by the National Cancer Institute, one of the 27 institutes and centers that comprise the National Institutes of Health.

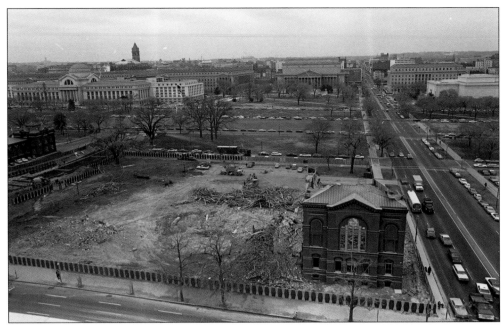

Demolition of the Old Red Brick took place in February 1969. The view above is looking north from the corner of Seventh Street SW and Independence Avenue SW. The Old Red Brick is in the foreground. In the background are, from left to right, the US National Museum (today known as the Smithsonian Arts and Industries Building), Natural History Building (today the National Museum of Natural History), Old Post Office Tower (today the Trump International Hotel Washington, DC), US Department of Justice, National Archives, US Federal Trade Commission, and National Gallery of Art. (Both, courtesy of the Smithsonian Institution Archives.)

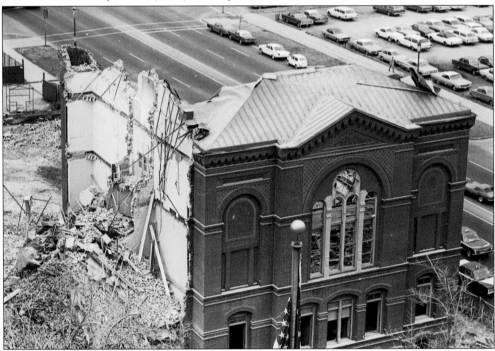

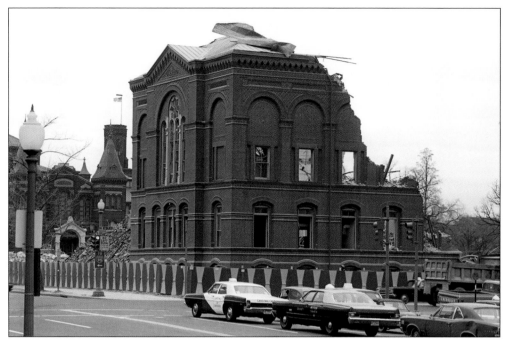

The northwest view of the demolition above shows the US National Museum in the background. Below is an up-close view of the demolition. (Both, courtesy of the Smithsonian Institution Archives.)

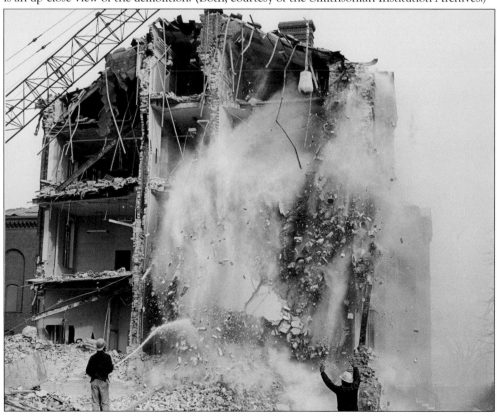

Sometime during or after the demolition, library and museum staff saved portions of the Old Red Brick. Over the years, they presented colleagues with these pieces as special gifts and mementos, often accompanied by a small printed card like the one pictured below, which reads: "From the 'Old Red Brick'; Home of Army Medical Museum, 1888–1946; Army Institute of Pathology, 1946–1949; Armed Forces Institute of Pathology, 1949–1968." (Both, courtesy of Stephen J. Greenberg.)

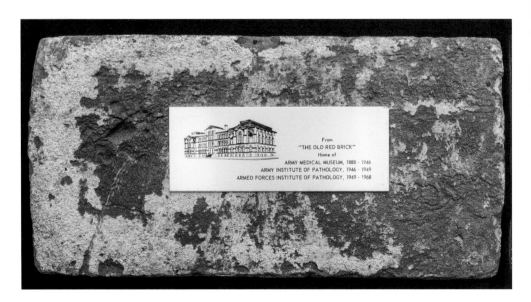

From
"THE OLD RED BRICK"
Home of
ARMY MEDICAL MUSEUM, 1888 - 1946
ARMY INSTITUTE OF PATHOLOGY, 1946 - 1949
ARMED FORCES INSTITUTE OF PATHOLOGY, 1949 - 1968

Donald A.B. Lindberg, MD, library director from 1984 to 2015, and Michael DeBakey, MD, celebrate DeBakey's 90th birthday (September 7, 1998) in the rotunda of the library on October 7, 1998. DeBakey holds a special gift—a piece of the previous home of the library, the Old Red Brick, dating from the 1880s and the time of John Shaw Billings.

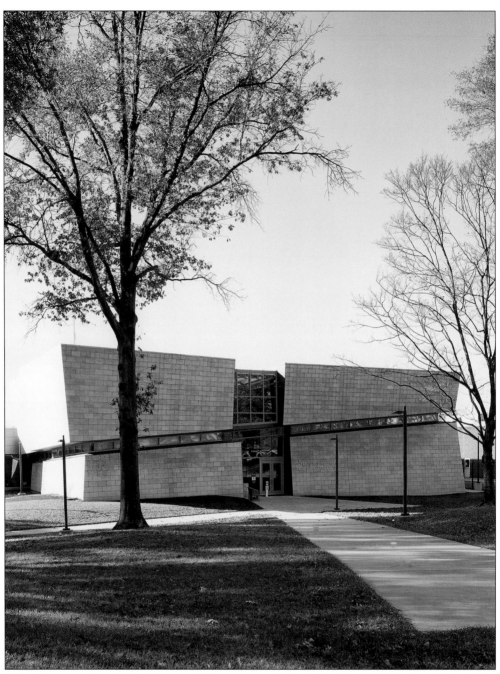

After the separation of the library and the museum, both physically, with the demolition of the Old Red Brick, and legislatively, each institution grew to fill important roles in national and international medical research and education. The museum remained under the control of the US Army until 2015, when it was transferred to the Department of Defense. Now known as the National Museum of Health and Medicine, it relocated to its current location in Silver Spring, Maryland, in 2011, where it remains open to the public and actively supports medical research and education. (Courtesy of Stephen J. Greenberg.)

Six

THE INFORMATION AGE

In the early 1960s, as the library settled into its new building, Americans were marveling at the dramatic advances in science and technology. Russian and US astronauts were making the first space flights, determined to land on the moon before 1970. The space programs spurred the growth of technologies such as transistors, integrated circuits, and mainframe computers. The first communications satellites were making transatlantic television transmissions possible. Likewise, polio vaccines, open-heart surgery, and new drugs were changing the practice of medicine. And Americans increasingly learned about these advances via television, which had existed only in science fiction a generation earlier. At the library, a quieter but no less radical change had been under way that would revolutionize medical and scientific communication. It began with a new system to organize, store, and retrieve medical literature data with computer technology: the Medical Literature Analysis and Retrieval System (MEDLARS), developed through the leadership of Frank B. Rogers, MD, the library's director from 1949 to 1963.

Advances in medicine and science, as well as good medical practice, depend heavily on access to recent research publications. Recognizing this, the library had compiled and published indexes of the medical literature since 1879. In the 20th century, as the volume of medical articles steadily grew, the indexing work became one of its chief services and occupied at least half of its staff. For each index page, the staff typed individual paper slips for each article citation and assembled them on a board to be photographed and printed. During the 1950s, the library began to automate the process, replacing the boards with punch cards that could be machine sorted and run through an automatic high-speed camera. This streamlined index production, but with scientific publication booming and more than 100,000 new articles to index each year, the library's leaders knew they would need a faster, more versatile system to keep up. They also wanted a system that would allow librarians to search a database of articles and retrieve bibliographies for patrons upon request. In 1961, the library contracted with General Electric to design MEDLARS, and in 1963, it acquired a Minneapolis-Honeywell 800 mainframe computer to run it. The system—the first computer-based bibliographic search service—became operational in 1964.

Library staff used punched paper tapes to enter MEDLARS data into the computer, and stored this data on magnetic tape reels. To search MEDLARS, a patron filled out a search form, which was then given to a search specialist, who built a search formulation using subject terms and other elements. Search requests were processed in batches, and patrons received the results in two to four weeks. From the start, the library intended the system to be decentralized—staff gave copies of MEDLARS (on magnetic tapes) to other large medical libraries to use with their own computers, and trained the search specialists at these institutions. The library also used MEDLARS

to create automated catalog records for new books. MEDLARS was an important first step in a new vision of medical libraries generally; no longer just places to store books and journals, they would be active information centers, using television, telephone, and computer technology to develop networks for communicating biomedical information quickly and to evaluate and develop new systems for information storage and retrieval.

In 1965, Congress authorized two major federal health programs, Medicare and Medicaid, as well as the Medical Library Assistance Act. Together, these initiatives would rapidly increase medical services and research and set the stage for developing better health care communication networks, including a network of regional medical libraries led by the library. Furthermore, library staff and the board of regents recommended to US surgeon general Luther Terry that the library should support experimental programs to test multiple approaches to meet the needs for biomedical information and be a national resource for information systems research and development within the public health service. Library leadership proposed establishing a national center for biomedical communications in a new building staffed by scientists doing research and development in information systems and developing and demonstrating methods for the continuing education of workers in the health professions. Congress authorized the center in 1968, and at the suggestion of the library's director, Martin M. Cummings, MD, named it in honor of Alabama senator Joseph Lister Hill, longtime advocate for health legislation and co-sponsor of the 1956 National Library of Medicine Act.

During its first decade, the Lister Hill Center staff tackled many challenges in cooperation with staff across the library. Together, they developed and tested an online system for MEDLARS, called MEDLINE (MEDLARS Online), which enabled users to enter search requests from remote terminals, via the Teletypewriter Exchange System, or TWX. The center also applied communications technology to medical education via an interactive television network and a computer-assisted instructional network that included a number of medical schools. In other projects, they demonstrated the usefulness of satellite communication for medical education and consultation, setting up connections to Alaska, Montana, Idaho, and Washington. Thus, medical students in Alaska could attend classes given at the University of Washington via satellite television transmissions. Physicians in remote areas could send electrocardiograms and other images to colleagues at larger medical centers and confer with them in real time.

In 1979, long before the Internet became part of people's daily lives, the library began to convert the remainder of its vast card catalog to machine-readable form so that the bibliographic information about its holdings dating from the 12th century to 1965 could be accessible to patrons online. This landmark accomplishment, one of the first of its kind in the nation, was completed in the early 1980s. When searching on the Internet became commonplace in the 1990s, the library, in 1993, was one of the first federal agencies to set up an Internet site. Since then, it has continued to lead in the field of medical informatics, support training and research through a variety of programs and grants, and play a major role in making the published results of biomedical research publicly available worldwide.

—Susan L. Speaker, PhD

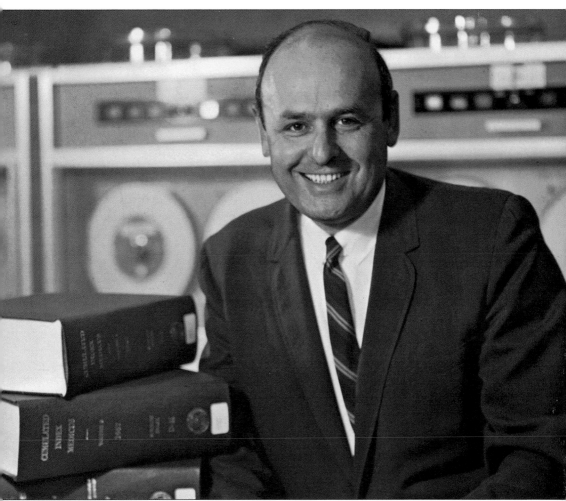

Martin M. Cummings, MD, was director of the library from 1964 to 1983. During his tenure, which began two years after the library's new building opened on the Bethesda campus of the National Institutes of Health, the mission of the institution as a health information resource expanded substantially. In the years that followed, the library emerged as a leader in the computer age, pioneering the use of the US Department of Defense Advanced Research Projects Agency Network (ARPANET), the precursor to the Internet, and becoming a major biomedical communications center.

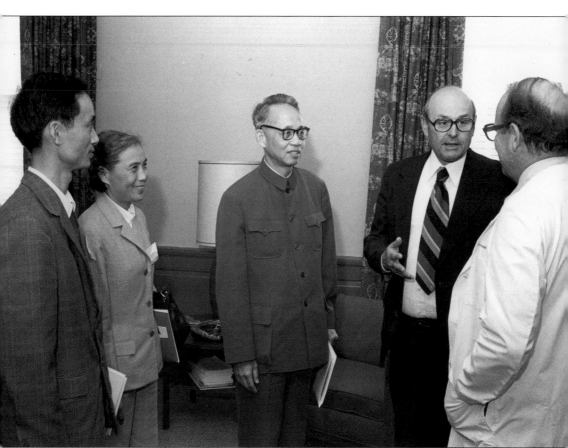

Martin M. Cummings, MD, meets with a delegation of Chinese officials in the mid-1970s. Cummings's leadership transformed the library from a national resource into a unique international force and one of the most advanced scientific libraries in the world. Testifying to this change were many visits by Cummings to the library and to other locations on the campus of the National Institutes of Health and overseas. From left to right are three Chinese dignitaries, Cummings, and Donald S. Fredrickson, MD, director of the National Institutes of Health from 1975 to 1981. The leadership tenure of Cummings coincided with President Richard Nixon normalizing American relations with the People's Republic of China. Between 1972 and 1978, five Chinese delegations visited the library to establish mutually beneficial relationships, from Chinese participation in MEDLARS to assisting the library in cataloging its collection of traditional Chinese medical literature. Cummings subsequently traveled to China in 1978 to solidify relations as part of a delegation of the American Association for the Advancement of Science.

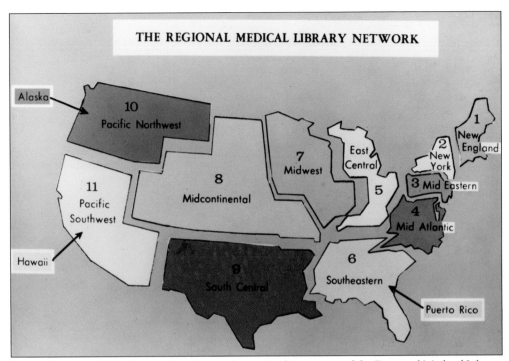

THE REGIONAL MEDICAL LIBRARY NETWORK

Alaska

10
Pacific Northwest

11
Pacific
Southwest

Hawaii

8
Midcontinental

7
Midwest

East
Central

5

1
New
England

2
New
York

3 Mid Eastern

4
Mid Atlantic

9
South Central

6
Southeastern

Puerto Rico

Dating from the 1970s, this graphic depicts the original 11 regions of the Regional Medical Library Network, established by the 1965 Medical Library Assistance Act, which had its roots in President Johnson's 1964 Commission on Heart Disease, Cancer, and Stroke. Proponents intended the Medical Library Assistance Act, and the networks it created, to strengthen America's system of medical libraries, to enable them to disseminate biomedical literature within their geographical areas, and to provide computer searches, copies of documents, reference services, specialized information centers, and training for library staff.

An Application Technology Satellite-1 (ATS-1) antenna sits next to a Native Health Clinic, established by the US Department of Health Education and Welfare, Public Health Service, in Galena, Alaska, around 1970. This technology, combined with the Teletypewriter Exchange System, or TWX, enabled the library to pioneer long-distance medical education and consultation.

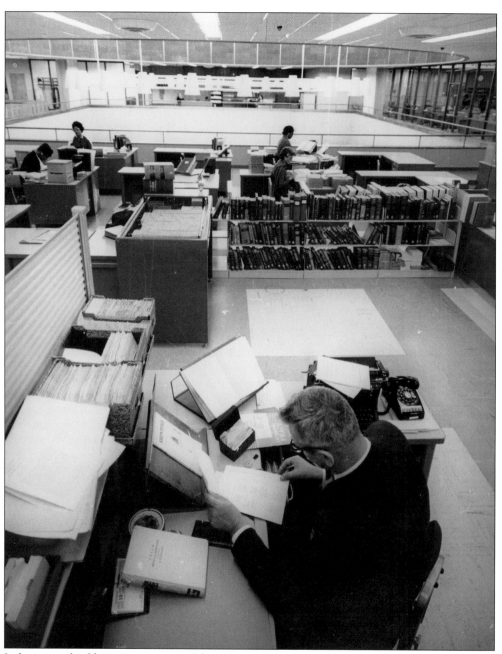

Indexing medical literature was one of the most significant programs in the library throughout the 20th century. Indexers created bibliographic citations for every article published in the thousands of medical journals covered by MEDLARS and, since 1971, MEDLINE. Among them was Stanley Jablonski, pictured here, a lexicographer who worked at the library from 1949 to 1976. He was a skilled linguist who could read and index medical literature in 10 languages. Jablonski played an active part in the development of MEDLARS and became head of the library's Index Section.

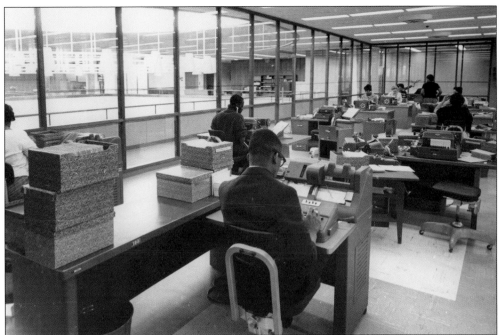

Technological advances helped to streamline the production of the library's indexes of medical literature. Beginning in the 1950s, the Index Section staff created punch cards that could be machine sorted to automate the production of the printed indexes. The glass wall above was intended to muffle the sound of the noisy machines; it remains a feature of the second-floor mezzanine of the library. Below, staff carefully analyze individual articles to identify main concepts and assign descriptors from a standard vocabulary known as the Medical Subject Headings (MeSH), which the library began publishing in 1960 to facilitate effective search and retrieval. Staff typed individual indexed citations on paper slips and assembled them on a board to be photographed and printed as an index to current medical research.

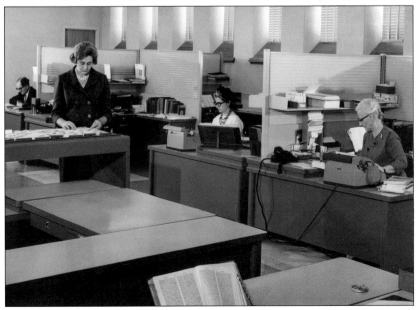

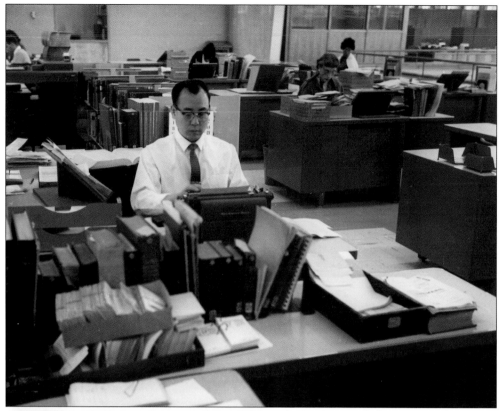

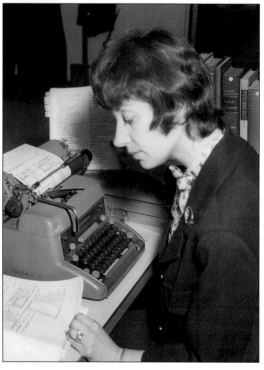

The MeSH vocabulary was quickly adopted by medical libraries for cataloging their own collections. MEDLARS was an equally significant accomplishment for the library. Establishing an online version of the system, MEDLINE, in the early 1970s opened it up to more medical librarians around the country and later to the world. Together, MeSH and MEDLINE proved to be invaluable tools for medical research. By the 1970s, staff members of the library and in medical libraries around the country were entering MeSH vocabulary into networked MEDLINE computer terminals to find relevant journal articles to answer patron inquiries both onsite and remotely. Indexers required in-depth knowledge in a wide variety of disciplines. Staff members might be called upon to review literature from any branch of science or medicine, and they often kept at their desks reference copies of textbooks, medical dictionaries, and foreign language dictionaries.

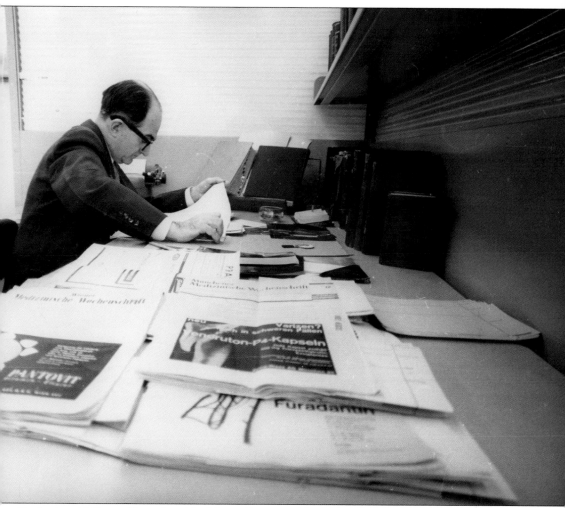

By the late 1960s, staff members like Henry Brown and his library colleagues faced the daunting task of reviewing an ever-growing list of medical journals, as the publishing industry exploded during the late 20th century.

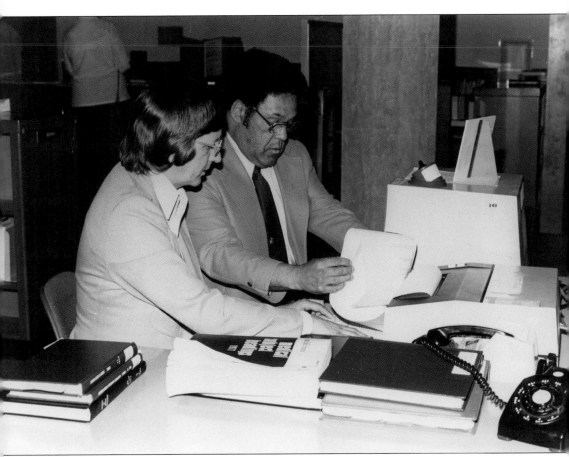

Librarian Howard Drew, right, works with a colleague to search MEDLINE to answer a patron inquiry around 1977. Drew was a highly decorated Army veteran who, over the course of his 36-year military career, earned 16 medals and citations, including the Soldier's Medal for Valor and the Legion of Merit. Drew was also an outstanding citizen of the community of the National Institutes of Health; in 1987, he became the first inductee in the agency's blood donor hall of fame.

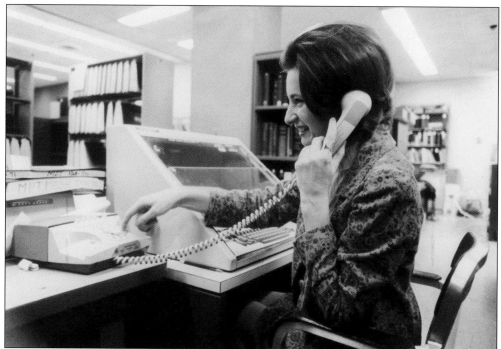

Librarians Gerry Nowak (above) and Yvonne Scott (right) use acoustic couplers (early computer modems) to establish a connection to a mainframe computer, which enabled access to MEDLINE in the mid-1970s.

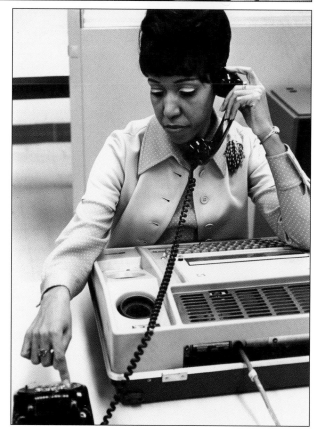

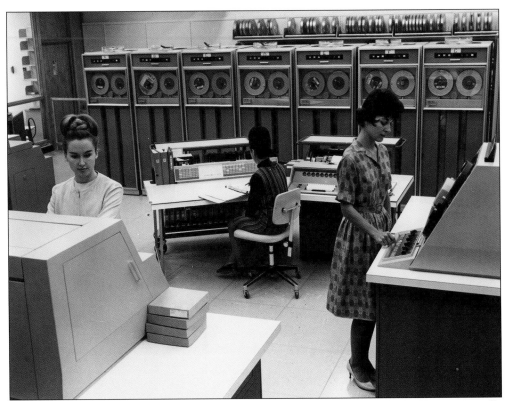

Above, computer operators work with the tape-driven Honeywell 800 mainframe computer, originally acquired by the library in 1963, which ran MEDLARS. The Honeywell 800 ran an assembly language called ARGUS (Automatic Routine Generating and Updating System). Prior to the arrival of the Honeywell computers, General Electric staff trained library staff in using ARGUS.

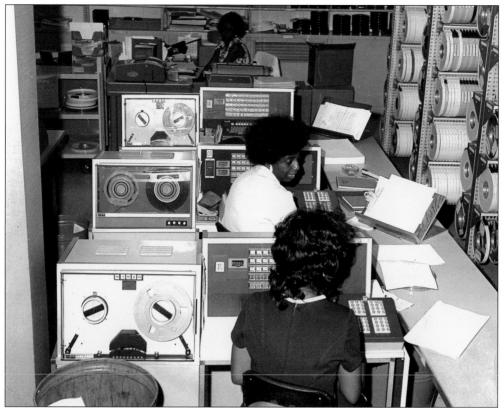

Data processing and storage took many forms at the library during the Information Age, from the magnetic tape reels pictured above, to cassettes, floppy disks, laser disks, and high-capacity fixed-disk memory banks. Such innovations were necessary to store the ever-growing volume of medical literature data. Below, library audiovisual specialist Fred Buschmeyer Jr. sits at one of the library's resource learning carrels in the mid-1970s. Here, patrons and staff could view and listen to a wide variety of medical audiovisual materials, including 35-mm slides, audiotapes, videocassettes, and 16-mm films.

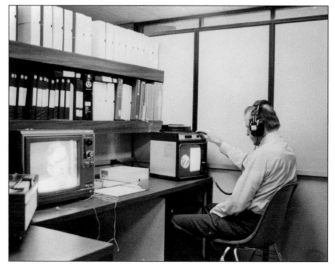

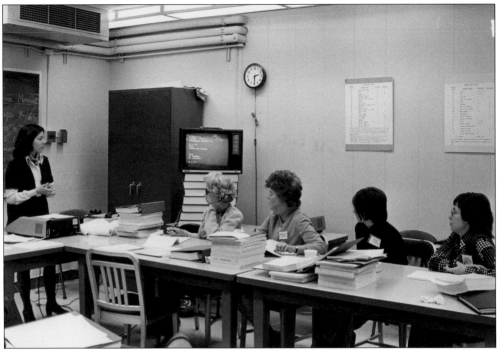

Librarian Patricia Burmeister teaches a library training class in the mid-1970s using a chalkboard, as well as emerging technology of the day—a dial-up modem and keyboard connected to a television. Training has always been an important activity at the National Library of Medicine. Advances in medical science and changes in terminology make it necessary for indexers and reference librarians to engage in continuous learning.

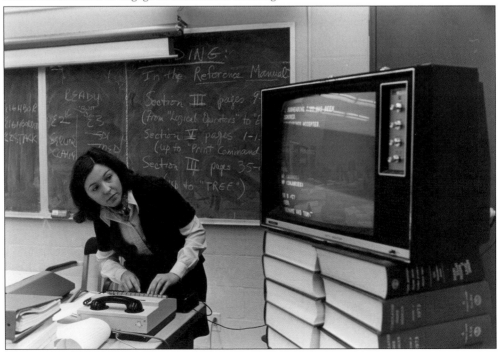

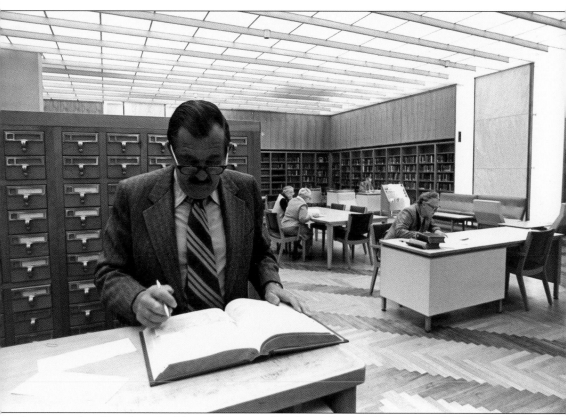

Patrons and staff work in the library's History of Medicine Reading Room around 1975. In the background, sitting at a desk at right, is historian Wyndham Miles, author of *A History of the National Library of Medicine: The Nation's Treasury of Medical Knowledge* (1982). A history of the library had been a dream ever since director Frank B. Rogers, MD, began to work on one in the late 1950s. Miles, a historian of chemistry, had been working as a historian for the National Institutes of Health since 1962. At the request of Dr. Martin M. Cummings, Rogers's successor as director, Miles began work on a history of the library. The bibliography of this book includes Miles's *History* among select other books and articles about the library, its history, and its collections and resources.

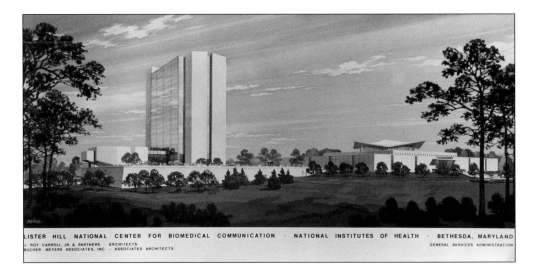

LISTER HILL NATIONAL CENTER FOR BIOMEDICAL COMMUNICATION · NATIONAL INSTITUTES OF HEALTH · BETHESDA, MARYLAND
J. ROY CARROLL, JR. & PARTNERS · ARCHITECTS
BUCHER·MEYERS ASSOCIATES, INC. · ASSOCIATED ARCHITECTS
GENERAL SERVICES ADMINISTRATION

Above is an architectural drawing of the library's Lister Hill National Center for Biomedical Communications by the firm J. Roy Carroll Jr. & Associates around 1978. In 1968, a joint resolution in Congress established the library's Lister Hill National Center for Biomedical Communications. The construction of the building of the same name did not begin until the George Hyman Construction Company was awarded the contract in June 1977. Although the center was physically different from the original library building, the architects designed it to be complementary, blending the two structures by using a common limestone facade and repeating the vertical, unbroken narrow column lines in the windows of the original building. Below, a northern view shows the construction of the center. The center expanded the footprint of the library on the campus of the National Institutes of Health and shaped the landscape of Bethesda.

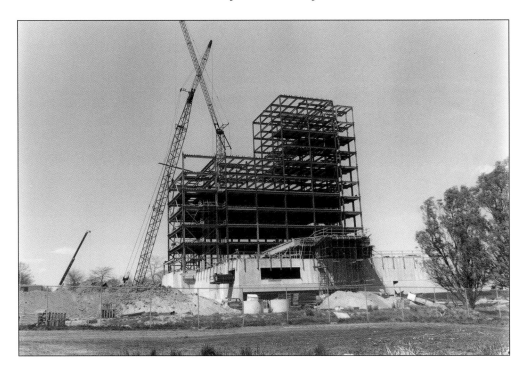

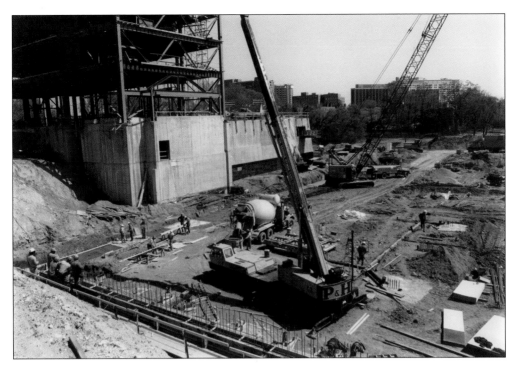

Above is a view of the construction of the library's Lister Hill National Center for Biomedical Communications looking south toward Bethesda in late 1978. This area would eventually become the location of the parking deck for the center. The view below from mid-1979 looks east as workers install portions of the limestone facade, with the original library building in the background.

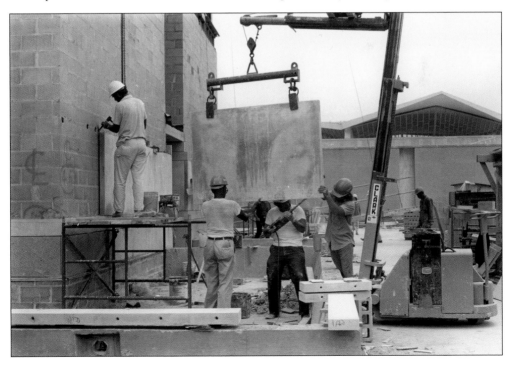

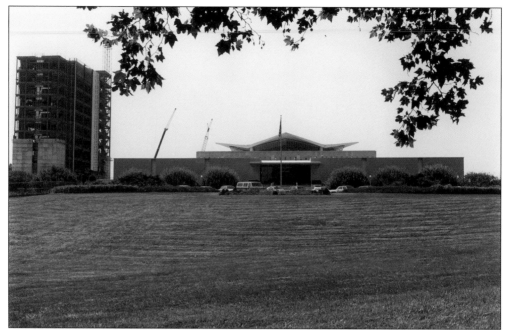

As the new Lister Hill National Center for Biomedical Communication arose, the vision of the library's director, Martin M. Cummings, MD, to launch a new era in biomedical communications became a reality. Below is an aerial view of the library in the winter of 1980, with Bethesda in the background.

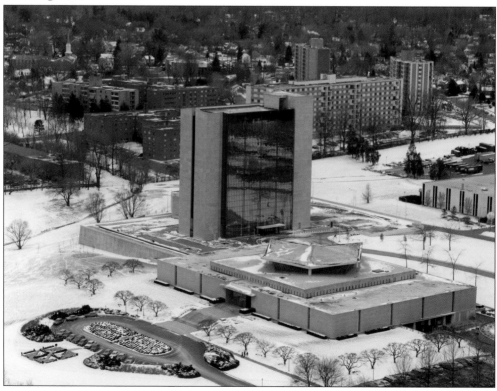

The library's MEDLARS III Task Force is shown here in 1979. Clockwise from left are Ben Erdman; Betsy Humphreys; Duane Arenales; Richard Dick, PhD; Grace McCarn; John Cox; Laura Kassebaum; Lillian Kozuma; and Joseph Leiter, PhD. Not pictured is Robert Schultheisz. MEDLARS II of the early 1970s added an online searching capability to MEDLARS. In 1980, the library completed the functional specifications for MEDLARS III, which sought to provide both greatly enhanced user functionality and more rational and integrated data creation and library processing capabilities.

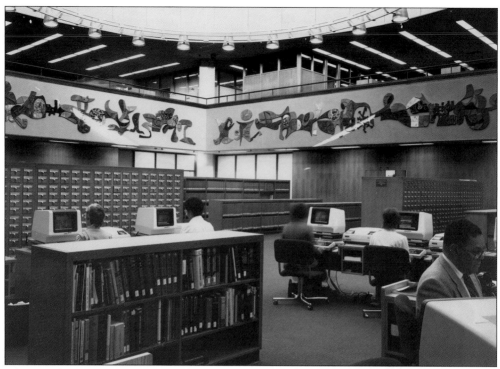

Above, online catalog terminals, introduced in 1983, are seen next to the card catalog in the library's rotunda. Below, a library staff member guides patrons in using these terminals.

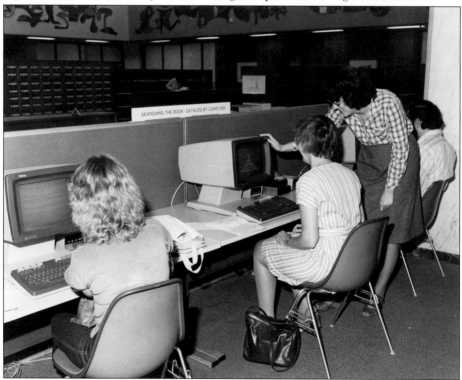

Seven

CELEBRATING 150 YEARS OF PUBLIC SERVICE AND LOOKING TO THE FUTURE

In late December 1985, a joint resolution passed by Congress declared 1986 the Sesquicentennial Year of the National Library of Medicine. It was a time to celebrate and reflect on a rich and diverse record of public service and to look ahead to the digital era. Only two years earlier, the library had welcomed a new and visionary director, Donald A.B. Lindberg, MD, an eminent pathologist and pioneering scientist, who, since 1960, had been applying computer technology to health care at the University of Missouri. Under his new leadership, the library's sesquicentennial became an ideal moment to take stock of the past and look to the future. In the words of President Ronald Reagan:

> One hundred fifty years ago, in 1836, what is now the largest and most distinguished medical library and medical communications center in the world was only a small collection of medical books in the office of the United States Army Surgeon General. That transition is an inspiring story—one that speaks of both the need of health professionals and researchers for rapid access to information and of the response to that need by a succession of dedicated and visionary leaders of the National Library of Medicine.

Only days after President Reagan's proclamation, dignitaries and guests, library leadership and staff, and members of the public gathered on Capitol Hill to inaugurate a series of events that would help to mark the library's sesquicentennial. Among the first was an open house at the library itself, its leadership and staff welcoming friends from across the National Institutes of Health, neighbors from around Bethesda, and colleagues from across the country. Visitors participated in tours of the institution, heard from staff who developed and managed a variety of information systems, and learned about the history of the library through a special sesquicentennial exhibition. The occasion underscored an important feature of the library since its relocation to the campus of the National Institutes of Health in 1962: it was a place open to all, where patrons could visit,

explore, and learn through individual research, conversation with library staff, and exhibitions that featured the treasured collections of the institution.

Events of the library's sesquicentennial year also included the opening of its new visitor center and a symposium on the history of vaccines involving Albert Sabin, the award-winning scientist best known for developing the oral polio vaccine. Two additional symposia, on the subjects of medicine and the arts and on space medicine, conveyed the diversity of the library's collections, programs, and connections to other organizations, including the National Aeronautics and Space Administration. The Friends of the National Library of Medicine sponsored a gala dinner and evening at Ford's Theatre, where the library was located from 1866 to 1887. The library also held a weeklong medical film festival featuring the award-winning productions of that year's John Muir Medical Film Festival.

Complementing the future-oriented sesquicentennial year of the library were several significant technological advancements. Staff enhanced MEDLARS by introducing Grateful Med, an innovative new software program for desktop computers that enabled individual health professionals and others without specialized search training to explore the millions of journal article references in MEDLINE. Additionally, staff initiated a research and development project to create a Unified Medical Language System, with the ambitious goal of helping computers to understand biomedical meaning, irrespective of the different terminologies and classifications used in medical information sources, including biomedical literature and patient records. Finally, there was the 1986 long-range plan of the library, designed to guide the institution in using its human, physical, and financial resources to fulfill its mission in a time of great change in science and widespread access to medical and related information. The plan identified 16 goals across five priority areas—building and organizing the library's collection, locating and gaining access to medical and scientific literature, obtaining factual information from databases, research and training in medical informatics, and assisting the education of health professionals through information technology. In the following years, library leadership and staff would update the plan in specific areas, with supplemental planning reports on outreach to health professionals (1989), electronic imaging (1990), information services for toxicology and environmental health (1992), the education and training of health science librarians (1995), and international programs (1998).

The closing years of the 1980s saw accomplishments that would fundamentally shape the future of the library and its contributions to medicine in the decades that followed. Coming directly out of the 1968 long-range plan was the recognition by the library's board of regents that the library must play a major role in the area of molecular biology information by creating a National Center for Biotechnology Information (NCBI). As envisioned, this center would deal with the increasing volume and complexity of molecular and genetic data and provide researchers with improved access and computing tools to better understand genes and their role in health and disease. With the powerful support of Rep. Claude Pepper, Congress authorized the new center through legislation signed by President Reagan in November 1988. The center would soon become a key participant in organizing and providing access to the results of the Human Genome Project, the international, collaborative research program whose goal was to provide researchers with powerful tools to understand the genetic factors in human disease and pave the way for new strategies for disease diagnosis, treatment, and prevention. Leaders of the Human Genome Project declared their work complete in 2003, when they had successfully mapped all of the genes—together known as the genome—of the species *Homo sapiens*. For the first time in history, scientists could read nature's complete genetic blueprint for a human being. Since this achievement, the center has become an internationally recognized source for genomic databases, software tools for analyzing molecular data, and research in computational biology, serving millions of Internet users every day.

—Jeffrey S. Reznick, PhD

Grateful Med was conceived and launched in the 1980s. At right is an internal library memo handwritten by director Donald A.B. Lindberg, MD, on November 29, 1985. With this memo, Lindberg selected the name for the product intended to help expand and ease access to library databases. The memo reads: "John Anderson, re name for new microprocessor based user front end to MEDLARS. Let's use Grateful Med. It is just too good to pass up." Below, John Anderson, director of the library's Office of Computer and Communications Systems (sitting), and reference librarian Rosemary Woodsmall (standing) configure an early version of Grateful Med.

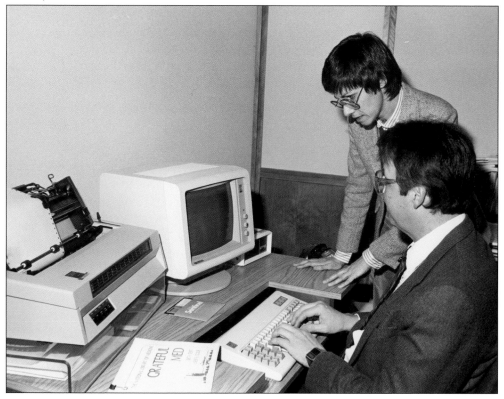

S. J. Res. 198

Ninety-ninth Congress of the United States of America

AT THE FIRST SESSION

Begun and held at the City of Washington on Thursday, the third day of January, one thousand nine hundred and eighty-five

Joint Resolution

To designate the year of 1986 as the "Sesquicentennial Year of the National Library of Medicine".

Whereas the National Library of Medicine houses the world's largest and most distinguished collection of health science literature in the world;

Whereas the National Library of Medicine has pioneered in developing the renowned MEDLARS system that provides worldwide access to this literature;

Whereas American health professionals, in research, education, and practice, have reaped great benefits from the communications systems and services provided by the National Library of Medicine;

Whereas the health of American citizens has been improved as a result of the rapid access to biomedical information enjoyed by health practitioners utilizing the services of the National Library of Medicine; and

Whereas the long and distinguished history of the National Library of Medicine is worthy of special commemoration by the people of the United States: Now, therefore, be it

Resolved by the Senate and House of Representatives of the United States of America in Congress assembled, That the year of 1986 is designated as the "Sesquicentennial Year of the National Library of Medicine" and that in recognition of the occasion of the one hundred fiftieth anniversary of the founding of the National Library of Medicine, the President is authorized and requested to issue a proclamation calling upon the people of the United States to observe such year with appropriate ceremonies, programs, and activities.

Speaker of the House of Representatives,
Pro Tempore

Strom Thurmond

~~Vice President of the United States and~~
President of the Senate Pro Tempore

APPROVED

DEC 2 8 1985

Ronald Reagan

Public law 99-231, approved on December 28, 1985, designated the year 1986 as the Sesquicentennial Year of the National Library of Medicine. President Reagan issued an official proclamation on January 29, 1986.

These posters designed by the library helped to announce its sesquicentennial and related public programs. Looking to the future and reflecting on the past went hand in hand during this landmark year of the library.

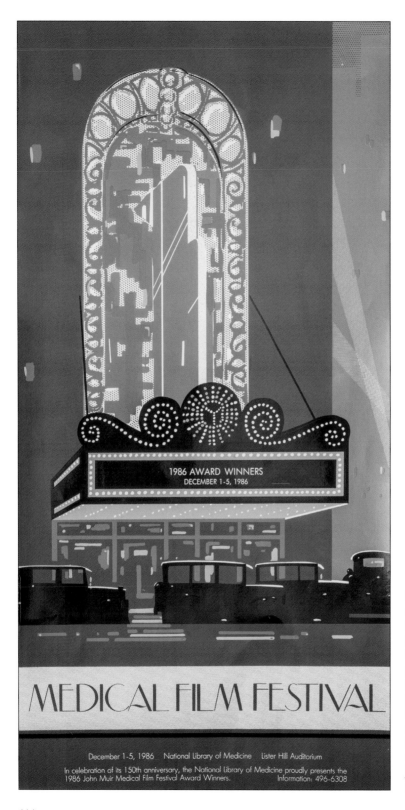

1986 AWARD WINNERS
DECEMBER 1-5, 1986

MEDICAL FILM FESTIVAL

December 1-5, 1986 National Library of Medicine Lister Hill Auditorium

In celebration of its 150th anniversary, the National Library of Medicine proudly presents the
1986 John Muir Medical Film Festival Award Winners. Information: 496-6308

During its sesquicentennial, the library sponsored a medical film festival for the public, screening more than 30 productions in its Lister Hill Center Auditorium. All the films were award winners at the 1986 John Muir Medical Film Festival.

Above, a poster-sized postcard from the Medical Library Association conveying 150th birthday wishes to the library was signed by members of the association who attended its annual meeting in 1986. The "stamp" is a copy of one of the several posters designed by the library to help announce its sesquicentennial and related public programs. At right are birthday wishes to the library from members of the Upstate New York and Ontario Chapter of the Medical Library Association.

The library celebrated 150 years of public service in 1986. Above, staff of the library gather on the front steps for a sesquicentennial photograph. Below are signatures of the staff on a commemorative copy of the photograph.

These catalogs of library exhibitions from the 1960s and 1970s show the variety of subjects covered by these public programs. Exhibitions held by the library during its sesquicentennial continued the long tradition of the institution offering such public programs based on its world-renowned collections and related resources. The tradition of curating exhibitions continues today through the library's award-winning exhibition program and internationally recognized traveling exhibition services.

The founding leadership of the library's new NCBI pose in the main computer room around 1988. From left to right are Dennis A. Benson, PhD; James Ostell, PhD; and David J. Lipman, MD. Not pictured is David Landesman, PhD.

Principals in the creation and direction of the new NCBI talk informally at the reception held in the Capitol's Mike Mansfield Room on February 21, 1989. From left to right are Rep. Claude Pepper, architect of the legislation that created the center; David J. Lipman, MD, the first director of the center; and Donald A.B. Lindberg, MD, director of the National Library of Medicine. Frances Humphrey Howard, a special assistant to the associate director for extramural programs at the library, and Kent Smith, the library's deputy director, are in the background.

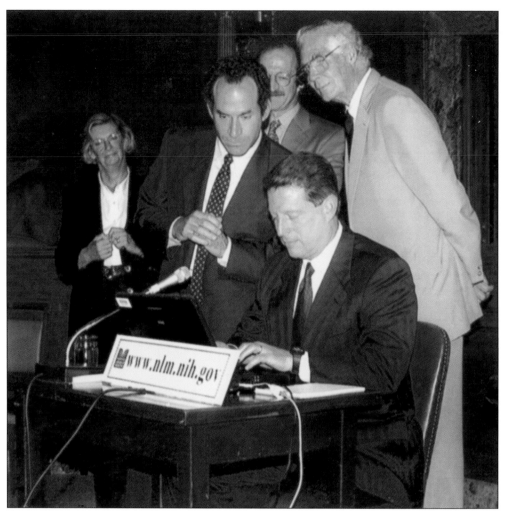

At a ceremony on Capitol Hill on June, 26, 1997, Vice President Albert Gore (sitting) introduced free MEDLINE searching via the Internet and demonstrated a new system developed by the library called PubMed, which simplified searching for online medical information by researchers and the public alike. Standing from left to right are Suzanne McInerney, coauthor (with Fred D. Baldwin) of *Infomedicine* (1996); David J. Lipman, MD, director of the NCBI; Harold Varmus, MD, 1989 Nobel laureate in Physiology or Medicine and director of the National Institutes of Health; and Donald A.B. Lindberg, MD, director of the library. The flexibility of PubMed and ease of use prompted Gore to say that free MEDLINE on the web "may do more to reform and improve the quality of health care in the United States than anything else we have done in a long time." As of 2016, more than three million people use PubMed daily as their source of medical information.

Eight

THE LIBRARY
IN THE 21ST CENTURY

Looking to the future has been a common theme in the history of the library. When Joseph Lovell sent the latest medical journals and texts to the department's medical officers in the field, he was well aware that such publications would be essential for current and future medical professionals. Interim Surgeon General Benjamin King requested funds to build what would become the core collection of the library, and Thomas Lawson sought to grow the collection into a legitimate library. When John Shaw Billings was posted to the Office of the US Army Surgeon General in 1865 and put in charge of its small collection of books, he soon envisioned creating the most comprehensive medical collection possible. As the collection grew, Billings realized that it needed to be "catalogued and open . . . as complete as it can be made" and searchable by subject, which had never before been possible. Over the course of the following century, generations of dedicated public servants—men and women from a variety of backgrounds—brought the vision of John Shaw Billings to reality: the US National Library of Medicine, the largest medical library in the world. Modern leaders of the library—from Harold W. Jones to Joseph H. McNinch to Frank B. Rogers to Martin M. Cummings—similarly looked forward as they engaged in the era of electronics and computers and what is known today to be the digital era, all to enable individuals across the nation and around the world to discover and easily use the library's collection for research, education, and clinical care.

Appointed to the directorship of the library in 1984, Donald A.B. Lindberg became the library's longest-serving leader to date, with a tenure of more than 30 years spanning the dawn of the 21st century. With his progressive, future-oriented leadership, grounded by his understanding and respect of history, and building on the important accomplishments of his predecessor Martin M. Cummings, Lindberg led the library into the digital age. During his tenure, technological innovations proliferated. To name only a few beyond those detailed in the previous chapter, 1990 saw the library embark on a collaborative effort to transfer the printed data of the massive and unique *Index-Catalogue* into an online, searchable database called IndexCat, which, 23 years later, the library released as Extensible Markup Language (XML) data for new, big-data oriented users and new uses in research, education, and clinical care; in 1994–1995, the library released the Visible Human Male and the Visible Human Female—modern digital anatomical atlases—which stand in a long and rich tradition of printed, layered human body anatomies; in 1997, the library

launched PubMed, which simplified searching for medical information and connected users of MEDLINE to the web sites of publishers of medical journals so they could receive the full text of journal articles identified in a search; in 2000, the library launched ClinicalTrials.gov, which has become the world's largest clinical trials database, and PubMed Central, an archive for full-text biomedical and life sciences journal articles; consumer-friendly MedlinePlus appeared in 1998, MedlinePlus en español in 2002; *MedlinePlus* the magazine, in 2006; and *MedlinePlus Salud* in 2009. These companion resources for patients and their families offer free and up-to-date information about diseases, conditions, and wellness issues in understandable language.

Hand in hand with these and many other innovations were achievements of library staff to bring the physical collections of the institution—and the stories of the human condition they hold—increasingly into the digital arena, to circulate freely beyond traditional reading rooms so they could be explored by people across the nation and around the world. Today, the library preserves and makes publicly available a constantly growing collection of nearly 30 million items. The institution is a global leader in information technology and distribution, and it remains the steward of one of the largest and most treasured history of medicine collections in the world. Every day, its electronic services deliver trillions of bytes of vitally important data to millions of people. Scientists, scholars, educators, health professionals, and the general public in the United States and around the world search the library's online resources more than a billion times each year.

In the years to come, the library's dedicated staff will continue to collect, preserve, and interpret for diverse audiences the broad and expanding scope of medical information, from material spanning the centuries—books and journals, still and moving images, manuscripts and ephemera—to "born digital" material like web sites and social media, as well as data generated by 21st century researchers.

It is the hope of the authors that this visual history inspires people to learn more about the library, to explore its collections and resources, and to appreciate the important role it plays as it enters its third century of preserving and providing access to current medical knowledge and to the medical heritage of the nation and the world.

—Jeffrey S. Reznick, PhD, and Kenneth M. Koyle

The fall 2006 edition of *MedlinePlus* featured a story about actress Mary Tyler Moore's fight against diabetes. Launched that same year to provide the best in reliable, up-to-date health information and the latest breakthroughs from research supported by the National Institutes of Health, this publication has featured individuals from all walks of life discussing how they have handled their health challenges. Available both in hard copy and online, the magazine complements the consumer health initiatives of the library and exemplifies an important chapter in its long history of providing health information to the public. In 2009, the library launched a Spanish version of the magazine, *MedlinePlus Salud*.

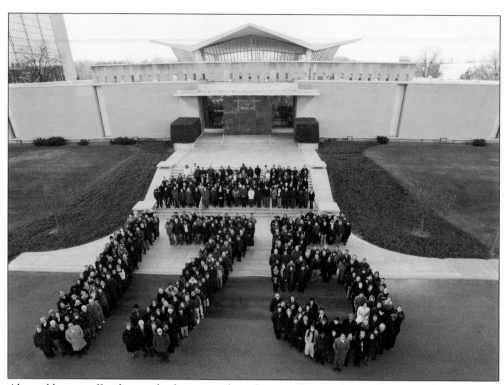

Above, library staff gather on the front steps for a photograph to mark the library's 175th anniversary in 2011. Their predecessors stood in the same location 25 years earlier to mark the library's sesquicentennial. The library will mark its bicentennial in 2036. Below, Donald A.B. Lindberg, MD, director of the library, speaks at a public program marking the anniversary and recognizes library staff—both past and present—for their public service. In the background is the library's official 175th anniversary logo featuring the time span of its service, 1836 to 2011, and the message of "Information Innovation."

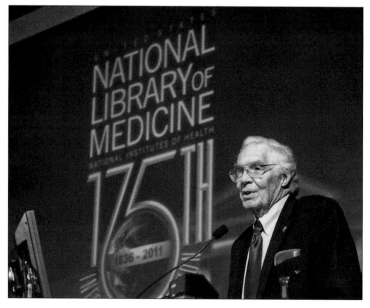

The 15-foot-long sculpture suspended from the ceiling of the library's rotunda represents the atomic constituents of DNA. A complete DNA molecule on the scale of this model would be 142 miles long. This sculpture was originally displayed in a 1969 exhibition on the work of Marshall W. Nirenberg, PhD, the National Institutes of Health research biochemist who, with his colleagues Har Gobind Khorana and Robert W. Holley, received the 1968 Nobel Prize in Physiology or Medicine for breaking the genetic code, discovering how sequences of DNA—known as "triplets"—direct the assembly of amino acids into the structural and functional proteins essential to life. (Courtesy of Stephen J. Greenberg.)

National Institutes of Health director Francis S. Collins, MD, PhD, (left) swears in Patricia Flatley Brennan, RN, PhD, as the 19th director of the library on September 12, 2016. Brennan's sister Jean Flatley McGuire is holding a copy of the US Constitution. Brennan was the first woman and first nurse appointed as director. Hundreds witnessed the historic occasion, a "great day for the National Institutes of Health," as Collins stated. (Courtesy of Ernie Branson and the National Institutes of Health.)

BIBLIOGRAPHY

Army Medical Library. *The One Hundredth Anniversary of the Army Medical Library*. Washington, DC: 1936. http://resource.nlm.nih.gov/57820930R

Blake, J.B. "From Surgeon General's Bookshelf to National Library of Medicine: A Brief History." *Bulletin of the Medical Library Association*. October 1986: 318–324. http://www.ncbi.nlm.nih.gov/pmc/articles/PMC406283

Brennan, Patricia Flatley. "Crafting the Third Century of the National Library of Medicine." *Journal of the American Medical Informatics Association*. 2016: 858. http://jamia.oxfordjournals.org/content/23/5/858

Gillett, Mary C. *The Army Medical Department, 1818–1865*. Washington, DC: Center of Military History, US Army, 1987. http://www.history.army.mil/html/books/medical_department_1917-1941/CMH_30-10-1.pdf

Metcalf, Keyes DeWitt. *The National Medical Library: Report of a Survey of the Army Medical Library*. Chicago, IL: American Library Association, 1944. http://resource.nlm.nih.gov/57810440R

Lindberg, Donald A.B. "The Modern Library: Lost and Found." *Bulletin of the Medical Library Association*. January 1996: 86–90. http://www.ncbi.nlm.nih.gov/pmc/articles/PMC226129

Lindberg, Donald A.B., and Betsy Humphreys. "Rising Expectations: Access to Biomedical Information." *Yearbook of Medical Informatics*. 2008: 165–172. http://www.ncbi.nlm.nih.gov/pmc/articles/PMC2441483

———. "High-Performance Computing and Communications and the National Information Infrastructure: New Opportunities and Challenges." *Journal of the American Medical Informatics Association*. May–June 1995: 197. http://www.ncbi.nlm.nih.gov/pmc/articles/PMC116254

Miles, Wyndham D. *A History of the National Library of Medicine: The Nation's Treasury of Medical Knowledge*. Bethesda, MD: US Department of Health and Human Services, 1982. http://resource.nlm.nih.gov/8218545

Sappol, Michael, ed. *Hidden Treasure: 175 Years of the National Library of Medicine*. New York, NY: Blast Books, 2011. http://collections.nlm.nih.gov/HiddenTreasure

Smith, K.A. "Laws, Leaders, and Legends of the Modern National Library of Medicine." *Journal of the Medical Library Association*. April 2008: 121–133. http://www.ncbi.nlm.nih.gov/pmc/articles/PMC2268223

Smith, K.A., and R.B. Mehnert. "The National Library of Medicine: From MEDLARS to the Sesquicentennial and Beyond." *Bulletin of the Medical Library Association*. October 1986: 325–332. http://www.ncbi.nlm.nih.gov/pmc/articles/PMC406284

US National Library of Medicine. *Past, Present, and Future of Biomedical Information. Based on a colloquium held in September 1986 to celebrate the 150th year of the National Library of Medicine*. Bethesda, MD: US Department of Health and Human Services, 1987. http://resource.nlm.nih.gov/8708723

INDEX

Discover Thousands of Local History Books
Featuring Millions of Vintage Images

Arcadia Publishing, the leading local history publisher in the United States, is committed to making history accessible and meaningful through publishing books that celebrate and preserve the heritage of America's people and places.

Find more books like this at
www.arcadiapublishing.com

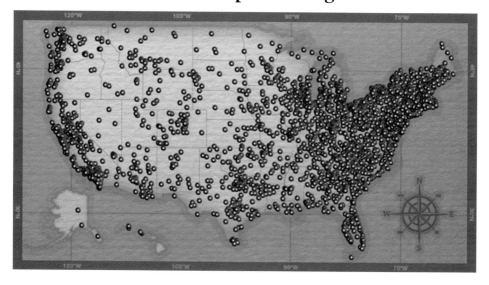

Search for your hometown history, your old stomping grounds, and even your favorite sports team.

Consistent with our mission to preserve history on a local level, this book was printed in South Carolina on American-made paper and manufactured entirely in the United States. Products carrying the accredited Forest Stewardship Council (FSC) label are printed on 100 percent FSC-certified paper.

MADE IN THE